THE BEGINNER'S GUIDE TO
Figure Drawing

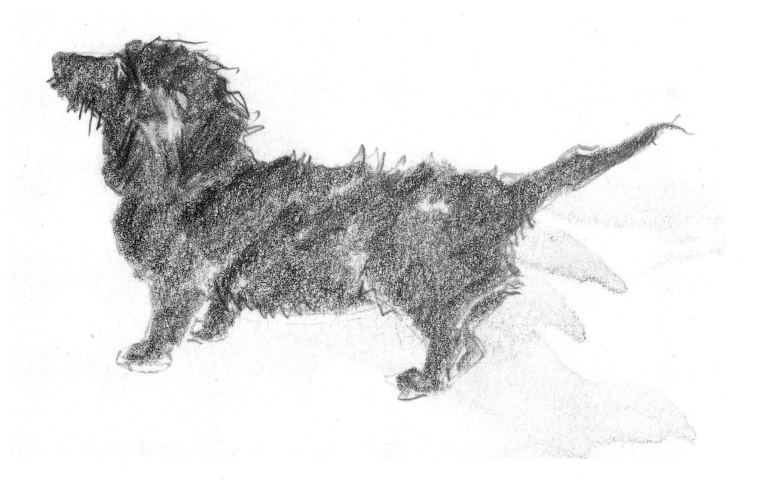

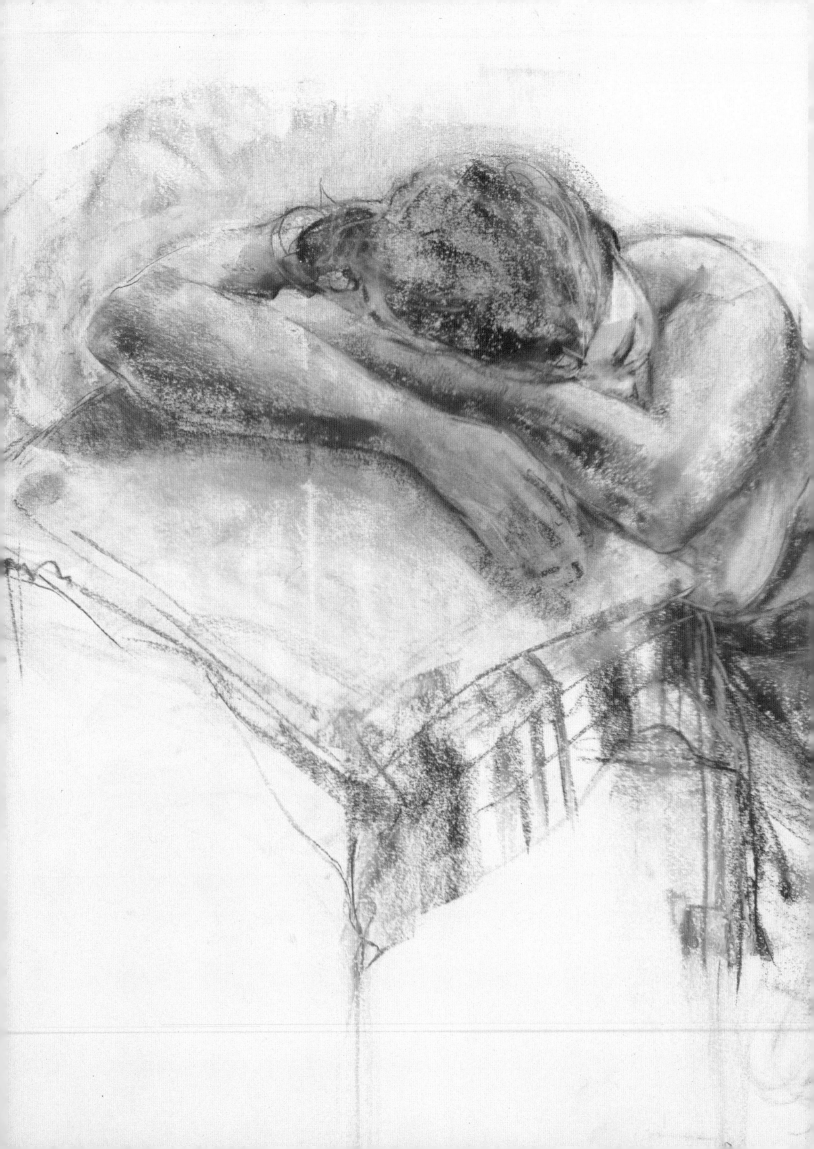

THE BEGINNER'S GUIDE TO

Figure Drawing

Viv Levy

CHARTWELL
BOOKS, INC.

Published by
CHARTWELL BOOKS, INC.
A Division of BOOK SALES, INC.
110 Enterprise Avenue
Secaucus, New Jersey 07094

Produced by
Brompton Books Corp.
15 Sherwood Place
Greenwich, CT 06830

ISBN 1-55521-854-7

Printed in Hong Kong
Reprinted 1994

PAGE 1
Viv Levy: *Small Dog* Pencil
PAGE 2/3
Viv Levy: *Model with Cushion* Pastel
RIGHT
Dido Crosby: *Male Model on the Move* Pen and ink

Contents

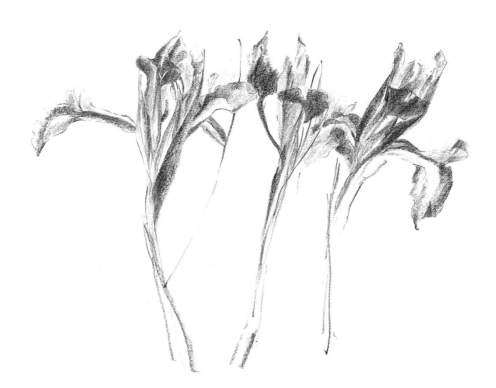

Introduction

'The discipline of drawing endows the fantasy with an element of reality, thus lending it greater weight and driving power.'

This is a guide to a new language, a rich, universal language that speaks to the eyes. I am assuming that you have picked up this book with no preconceptions about how drawing should be taught. I will not be addling your brain with the mysteries of anatomy or the intricacies of the skeleton. Our anatomical structure is, of course, indispensable but this is a book about seeing and, unless you are blessed with X-ray vision, dealing with the parts you cannot see will only confuse you. My aim is to demystify, not to bombard you with the second-hand methodology of academe. Details of the internal anatomy become relevant once you have identified a particular problem, when perception belies understanding. I will not be encouraging you to dissect your victim and to name the parts, but to look at the subject in its entirety, to believe the evidence of your eyes, and to transfer what you have seen on to the page. Simple. Nothing must be taken for granted; you may assume that you know what a foot looks like but I'm willing to bet that you have never really LOOKED at one. Worthiness alone is not the key to learning and will do little to boost your morale; be prepared to enjoy yourself.

Before you transform that seductive, alarmingly pristine sheet of paper, before you make your first mark on it, and change it forever, then stick it on the wall or consign it to the bin, ask yourself why it is you want to draw. Have you always wanted to and is this, finally, it? Are you informing another passion, using drawing as the 'basis and theory of painting and sculpture' (Ghiberti), as the science of the arts? Have you come to improve your hand/eye co-ordination? Or will your drawings be entities in themselves? Silent poetry.

Drawing can be all or any one of these things, a service area or an end in itself. As stretching and limbering are to dance, practicing scales is to music, reading to writing, so drawing can instruct and enrich another discipline. But it is not just the basis and

theory. It does train hand/eye co-ordination, if you persevere; it can serve as an aide memoire, as raw material or as working plans for painting, sculpture or design. It is also, however, a language in itself, a language of mind minus words, a visual shorthand that will enable you to select, condense, distort, emphasize and re-invent your subject. It frees the subconscious, jogs the memory, forces you to look, teaches you to see. Whether you are limbering, recording or creating, it is essential that you believe the evidence of your eyes.

So why 'Figure' drawing? Is the unclothed

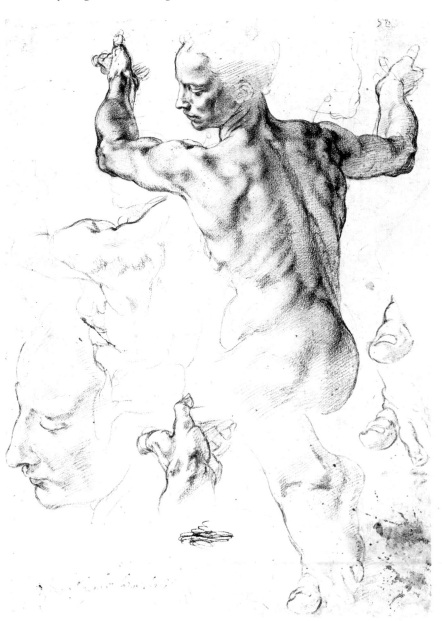

BELOW
Michelangelo
Drawing for the *Libyan Sybil*, c.1511
Red chalk

RIGHT
Michelangelo
Libyan Sybil
Sistine Chapel ceiling
This is an example of a disciplined study being transformed to serve the artist's imagination; conversely, the discipline of the drawing has endowed the fantasy with an element of reality.

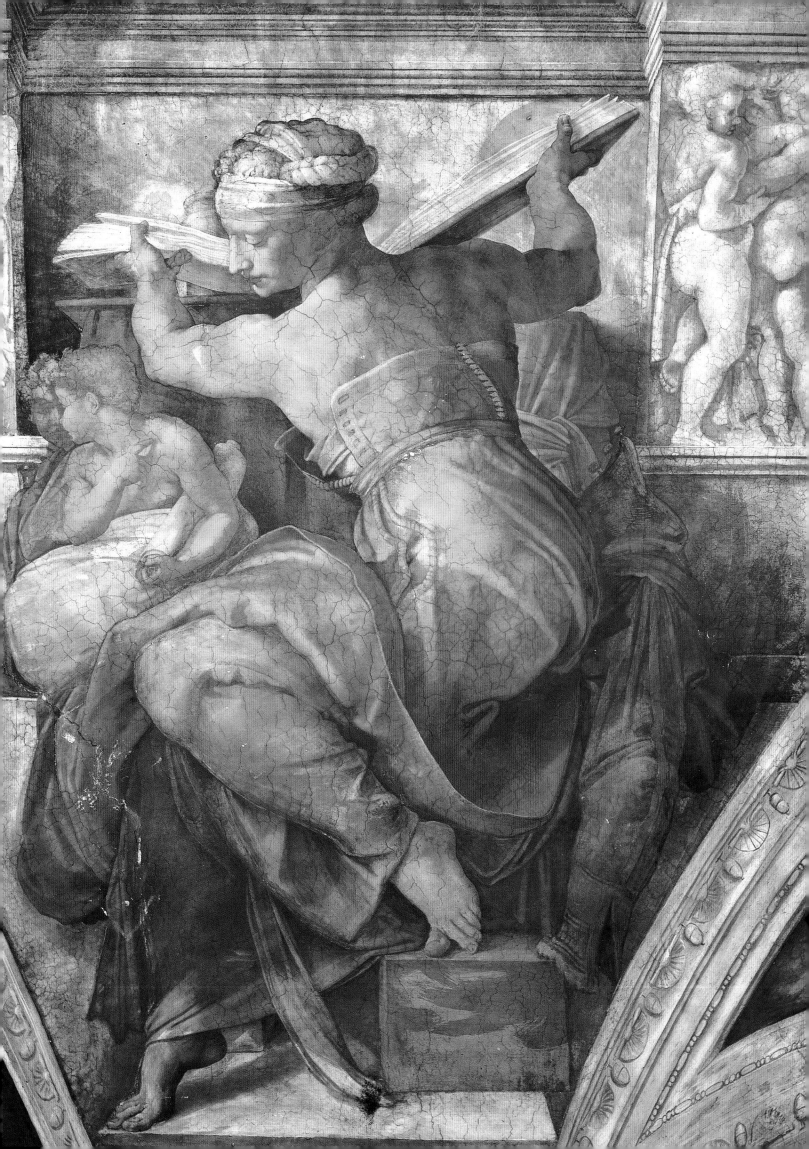

human figure the only form of life that qualifies for inclusion in this category? I imagine that few of us are blessed with an available nude, drifting around our homes, ready and willing to freeze into excruciating poses for us to draw, nor is it likely that we own huge mirrors, efficient heating and the privacy and confidence to disrobe and draw ourselves, warts and all. You may be consulting this book as a spur to get you to a formal Life Class, but it is more probable that you are looking for information and exercises to keep you going when other options are unavailable. My definition of 'Life', therefore, will include plants, animals and clothed figures; our familiars who are available, who will welcome all the attention and scrutiny we lavish on them and will not be unduly horrified, or insulted, by our first self-conscious attempts at their likenesses.

Why 'Life' when there's a world of inanimate objects just waiting to be drawn: architecture, museum collections, interiors, figments of the imagination, patterns and traces of memory? 'Life' is the ultimate challenge: a life drawing must seize the moment, convince the viewer that the sitting figure may rise, the sleeping dog may wake, the flowering plant may wither. The face reveals something about the mind; the stance,

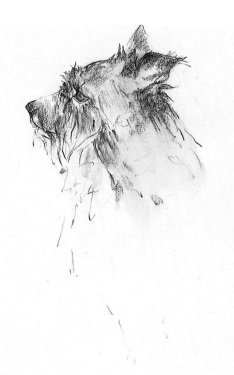

LEFT
Viv Levy
Quince
8b pencil, 5½ × 4⅛ inches
(142 × 105 cm)
Portrait of my dog. I had to grab it in about thirty seconds; additional information was culled from years of looking and the experience of previous drawings.

human or animal, is a key to character; the condition of a plant is synonymous with the seasons changing.

In his *Testament Artistique*, Rodin said that 'Nature should be your Goddess'. Here is a lifetime's study; nature's astonishing mechanical inventions, juxtapositions of form, line and texture, constantly on the

BELOW
Viv Levy
Giraffe Skull

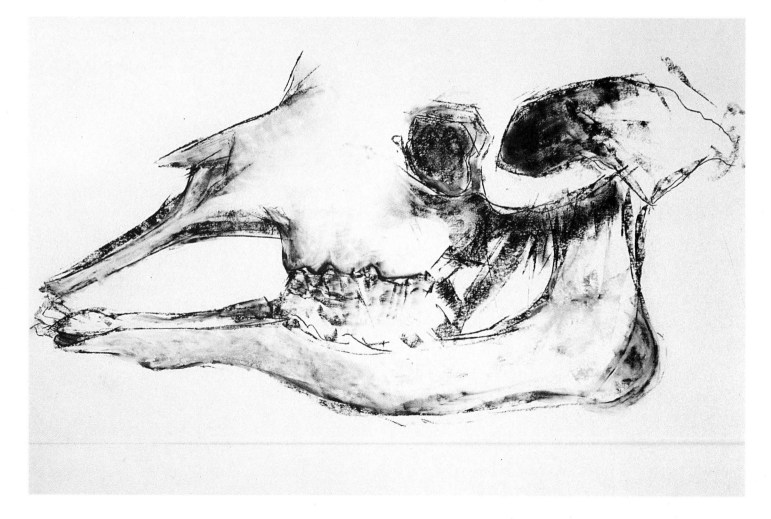

move, growing, changing color, surviving in the face of enormous odds. Imitate the way nature works, not the way she dresses, and you can't go wrong. Where better to look for the genesis of a drawing, a feast for the eye, a lesson. It is true that once you have really looked at a subject, once you have drawn it, you will never forget it.

Finally, ask yourself what constitutes a 'good' drawing. There is no pat answer. You will recognize it when you see it; it will bear the stamp of the individual who made it. This 'signature' has nothing to do with style, good taste or fashion; when drawings, or any work of art, are encumbered with self-conscious pre-occupations, truth flies out of the window. Empathize with nature, don't just record a pleasing corner of it; work with passion and concentration, energy and joy, and your unique character will emerge.

'The drawing that comes from the serious hand can be unwieldy, uneducated, unstyled and still be great simply by the superextension of whatever conviction the artist's hand projects, and being so strong that it eclipses the standard qualities critically expected. The need, the drive to express can be so strong that the drawing makes its own reason for being. – David Smith, 1905-65, American sculptor.

LEFT
Dido Crosby
Page from a sketch book: *Model on the Move*
Pencil, 11½ × 8 inches (29.4 × 20.5 cm)
An elegant and spare drawing, but you nevertheless understand the back view and are able to imagine the model continuing slowly to move around, across and off the page. The faint drawing of the bird (top left) balances the composition and tickles the fantasy button.

1. How and Where to Start

Do not rush in, grab the first scrap of paper to hand, seize a magic marker, take a perfunctory glance at the subject and expect to dash off a stunning likeness. Choose your materials with care and set yourself up so that your concentration is not repeatedly broken by expeditions to the west wing for an eraser, another color or something more suitable to wear.

Choose and set up, or pose, your subject with care. Make sure that you have a good view. Animals are unpredictable so check that you are not adjacent to something for them to hide behind or under; you could find yourself spending the rest of the day talking to the underside of the sofa. Animals can also make excellent subjects, however. My dog is a natural performer and collapses into outrageous poses at the lift of a pencil, even in a crowded class.

Choose your paper with care. If you match the texture of the paper to the medium you are using you will already be ahead of the game (see Materials, page 16). Cut your paper to scale; do not worry about standard sizes, you may want to work in a circular format, in a square or on a long narrow strip (useful for moving figures). Do not start by making a giant drawing of a small plant, a life-sized drawing of a human figure or a miniature of an elephant; we'll talk about going against the grain later. Ensure that your paper is the right way up, i.e. 'landscape' or horizontal for reclining or horizontal poses, 'portrait' for standing or vertical. (Again there may be instances when you want to set your figures in opposition to the frame.)

Make sure that your paper is secured to a sympathetic surface. Judicious use of masking tape or bulldog clips before you start will spare you the torment of pursuing your work around the floor, chasing unpredictable marks around the page, creasing or tearing the page while erasing, or engaging in enthusiastic frottage.

Choose your medium with care. It must not only be capable of caressing the paper but should also flatter the subject. The delicate mark deposited by a soft HB pencil may

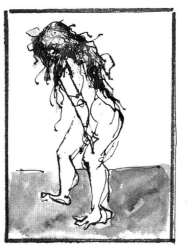
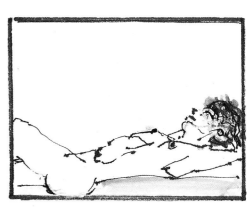

be the very thing for an intimate study of a dung beetle, but prove a useless ally for the sensual contours of a well-rounded female form or the fluid movements of a cat. The scale of the mark should be compatible with the size of the paper. Do not approach a 4 foot×6 foot expanse of paper brandishing an eyeliner brush, unless you fancy yourself as a budding pointillist, or confront a meager sketchbook with a dripping, six-inch house-

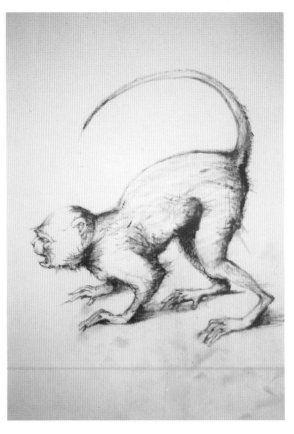

LEFT
Bryan Kneale
Monkey
Oil on greaseproof paper. This monkey is alive and poised to do mischief. The artist has captured the likeness of this creature as well as providing an insight into its personality. There is no sentimentality, no indecision, in the mark-making or the image.

RIGHT
Dido Crosby
Male Model on the Move
Pen & ink, 11½ × 8⅛ inches (29.4 × 20.8 cm)
With no time to gild the lily, detail is scant but the seeing and understanding are all there. A case of less saying more. Ink cries out for large confident decisions, even though the drawings may be small.

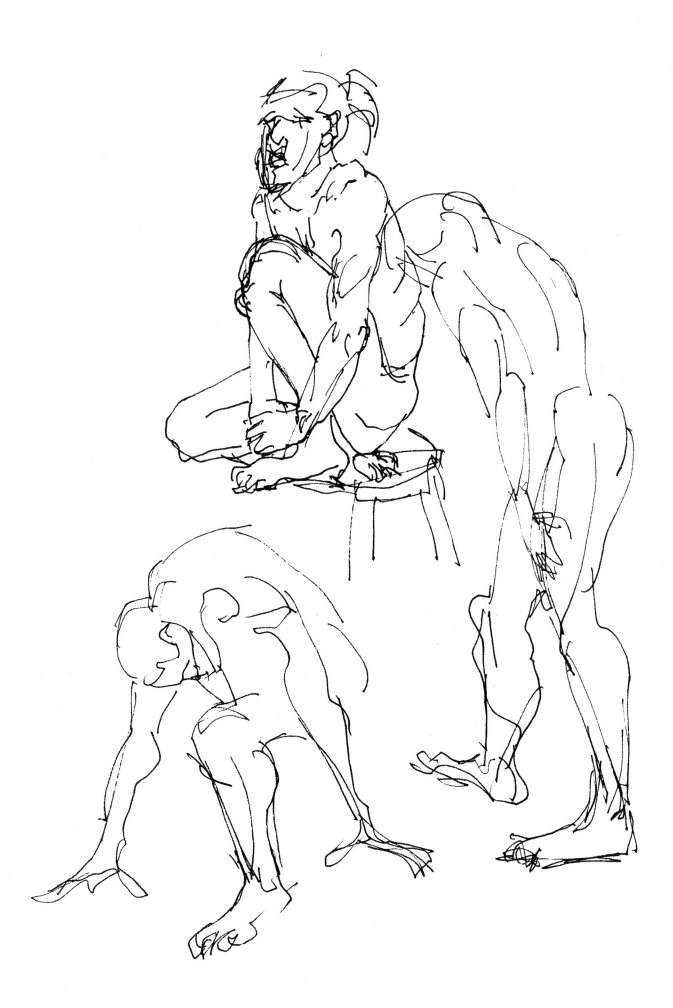

hold brush or a fistful of extra-soft charcoal (see Dictionary of Marks, page 19.)

Do not become addicted to one medium just because you feel secure with it. You are aiming to surprise yourself and enrich your vocabulary. Learn to enjoy losing control.

The way you arrange yourself, your stance, is as important as the comfort and well-being of your model. You may sit at a table, as long as only the hands and fingers need to travel across the page, but be sure that the table is not obscuring your view. You may squat on the floor for larger work, when the whole arm comes into play, or when you are using a wet medium and want to avoid drips. Remember that when you are working on a horizontal surface the thing that you are drawing will be perpendicular to you; you are not getting the same view of both the subject and the drawing. This dual perception causes images to become elongated on the page, especially with larger drawings. If you decide to prop your work on an easel or staple it to the wall, STAND UP and make sure that the center of the page is at, or just above, eye level. You will now be able to use your whole body. You will be able to continually stand back from the work, without causing an avalanche. Be sure there is nothing behind you; they say that sculpture is the stuff you trip over when you step back to admire a painting.

You need to be in the right frame of mind to pull off a lively drawing: a state of relaxed tension. You will need to be focused, brimming, quivering with concentration, with skinned eyes and a relaxed body. Don't clutch your pencil/pen/charcoal/brush, in a vice-like grip – it will not escape; and don't make infuriating little stabs at the paper. Be bold, be loose. Choose something interesting to draw. The world is your oyster, don't bore yourself into a state of indifference by picking an unsympathetic subject or a flabby pose. Be prepared to take chances and you will discover something new: when drawing takes over, amnesia sets in and time flies.

The American sculptor Alexander Calder (1898-1976) summed up the difficulties of drawing animals: 'The pose, or rather lack of pose, of the animal will often prove a disturbing element. Sometimes the beast will be reclining, probably asleep. Then unless

ABOVE
The problem of drawing on a horizontal surface: the subject of the drawing and the work exist on different planes and you will undoubtedly get some distortion on the page (usually elongation of the image), which will become visible when you lift the work onto the vertical plane.

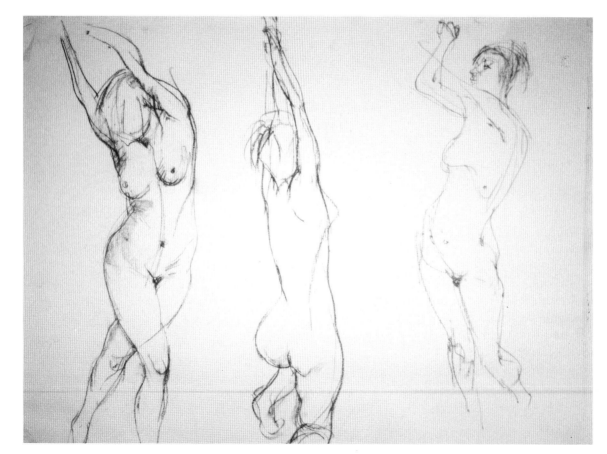

LEFT
Bryan Kneale
Moving Figure
Conté, 8⅛ × 11½ inches
(20.8 × 29.4 cm)
A relaxed arm and hand and focused looking result in a loose drawing that flows with the model.

he is in the throes of a nightmare, it will be easy sailing, provided you get a good vantage point. However, if he is on the move there may still be two possibilities. The animal may be repeating a cycle of motions, as a caged lion paces back and forth, or it may perform the action only once, as a dog may yawn. In the first case it is possible to wait and observe and study the action, thus building up one's knowledge with repeated views of the same thing. In the second instance, memory and impressionableness come into play very strongly as well as ease and speed of execution.'

There is always a feeling of perpetual motion about animals, and to draw them successfully this must be born in mind. Remember that action in a drawing is not necessarily physical action. A cat asleep has intense action. When an animal is in rapid motion, keep rapidly transmitting your impressions of the animal's movement, and enjoy what you are drawing.

If you are drawing a human animal, don't worry if he/she breathes, twitches, droops, sneezes or scratches; incorporate the quirks and realities of being alive into your drawing. Don't blame the model for a bad drawing. Draw from photographs at your peril. Unless you have selected a particularly inept photograph, the camera will have done your editing for you. There is nothing left for you to do but to slavishly copy a view taken through a mechanical lens. Many people find it easier to work from two-dimensional images. It is as if being able to touch perspective makes foreshortening and illusion comprehensible; something or someone has digested your looking for you. Shutting one eye flattens three-dimensional objects. Be prepared to grimace, to measure, to peer at your work in a mirror, to look and to look and to look again until you understand what you see.

People and animals talk back. If you feel unnerved at the prospect of a conversation, other than the one you should be having with yourself and the drawing, start off by tackling a plant. Don't talk to that plant.

You have chosen your model; you have found the best view; you are poised, pen in hand. Wait – there is another decision to make. If this drawing is to be more than an adequate copy it must have a direction of its own, content and meaning, or it will be no more than the page of a diary which catalogues events without reference to atmosphere, feeling or humor.

Be ambitious.

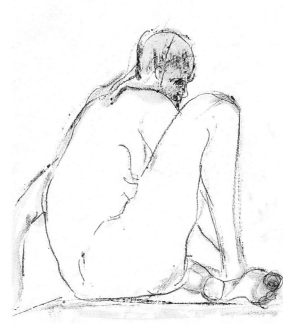

Viv Levy
Lady Weight Lifter
Same subject, different media and focus:

LEFT
Oil pastel and turpentine wash, 16¼ × 11¼ inches (41.6 × 28.8 cm)
The model is placed low on the page and the background has been cropped out.

BELOW
Charcoal and white pastel. Here the model is placed firmly on her plinth, further up the page and with some indication of the background, which affects the atmosphere of the drawing.

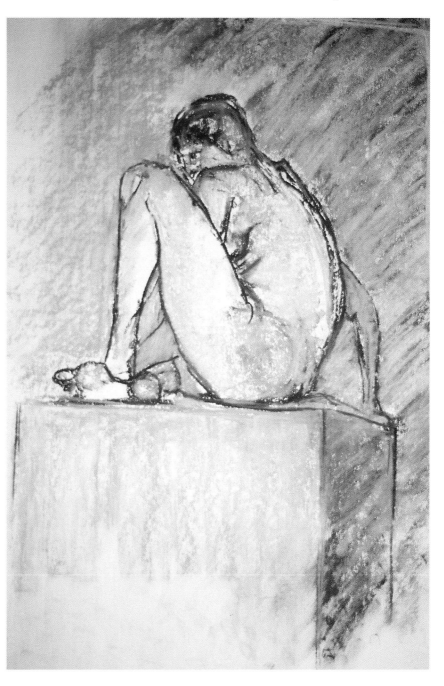

2. Materials and Dictionary of Marks

Technique is what belongs to others.
Technique is what others call it when
you have become successful at it.
Technique as far as you are concerned
is the way others have done it
Technique is nothing you can speak
about when you are doing it.
It is the expectancy of impostors.
 They do not show a
 respect for themselves
 or for what they are doing.
 – David Smith

To an extent technique can be taught; it is a
mechanical skill. Once you have mastered it,
you can use it to serve inspiration and more
or less forget about it. I have no secrets to
disseminate; technique in drawing is so sub-
jective that you may want to employ some
means which is traditionally frowned upon
to serve your needs. I will tell you some of
the facts about materials and leave you to
evolve your own technique. Only practice
will improve manual dexterity. There are no
magic formulae, so you should try things
out for yourself, extend your range and
don't trust other people's methods.

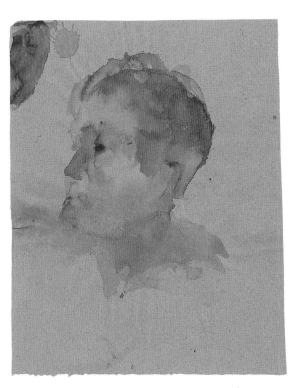

 It is difficult to define the dividing line
between drawing and painting. Some asso-
ciate drawing with a dry medium and mono-
chrome, painting with a wet medium and
color, drawing with paper, painting with

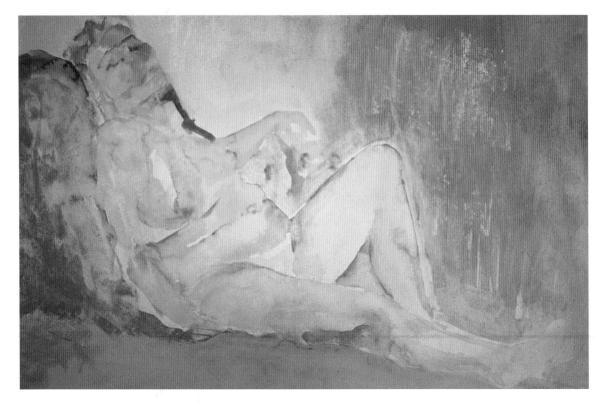

LEFT ABOVE AND BELOW
Viv Levy
Two drawings in
watercolor, on brown
paper.
Although the medium is
wet, colored and applied
with a brush, I consider
these pieces to be
drawings. The model was a
colorful character but
looked sad and tired that
day; it was her 'look' that
suggested the medium.

RIGHT
Leonardo da Vinci
*A Star of Bethlehem and Other
Plants*, c.1505-08
Red chalk and pen and ink,
7¾ × 6 inches (19.8 × 16
cm)
No one would dispute the
placing of this drawing in
the 'study' category, but
still it stands on its own as
a great work, regardless of
intention or function.

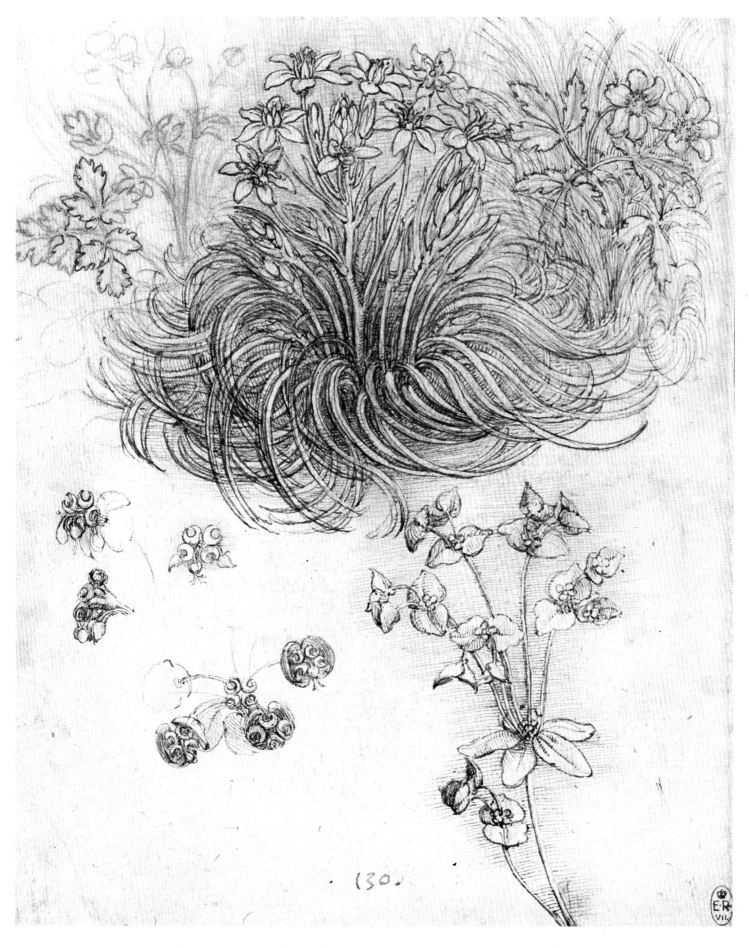

canvas. Pre-Renaissance drawing was made directly on to the wall and was then painted in. Leonardo da Vinci (1452-1519) changed this for ever by using drawing as a separate discipline, either as a plan on paper for a subsequent masterwork or as a study in itself. Do not allow any preconceptions you may have about the nature of drawing to restrict your ambition; experiment with materials and techniques.

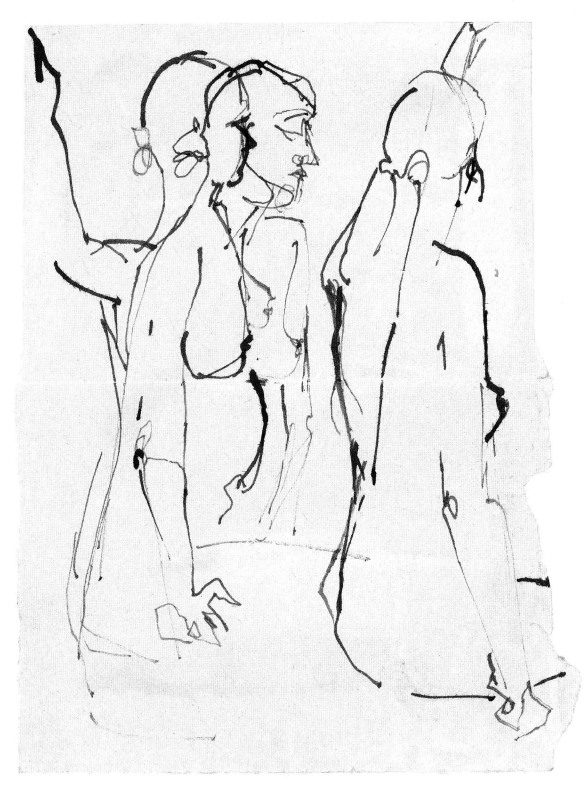

LEFT AND RIGHT ABOVE
Viv Levy
Moving Model
Stick and ink on the back of
an envelope, stick and ink
on newspaper.
Speed was of the essence
here: scrap paper was all I
could lay my hands on, the
stick had parted company
with a redundant sculpture,
the ink was purloined, but I
was able to knock out some
drawings while
simultaneously teaching a
class. I enjoyed the
unpredictable movement of
the line and the random
behavior of the ink on
absorbent paper.

Materials

I have already mentioned the importance of choosing paper and a medium appropriate to the task in hand. Obviously you will not want to spend a fortune at the outset. It is quite normal to lose all sense of proportion and go completely crazy in an art supplier's shop, ending up with an enormous collection of goodies that you will never use, and a large dent in your bank balance. Don't fall prey to expensive collections of pencils beautifully displayed in designer boxes. Breaking up the set will unhinge your mind.

The same goes for sketchbooks; exotically bound books of expensive hand-made paper will undoubtedly put the fear on you and inhibit your ability to let go. Don't buy ready-made kits. Someone has had a lot of fun putting temptation in your way but they cannot anticipate your needs.

My suggestions are:
1. A pile of very cheap paper, such as newsprint, brown wrapping paper or old newspapers. You will have no compunction about ruining paper destined for the garbage; you may even improve it out of recognition. Some of my liveliest drawings

have happened on the backs of old coffee-stained envelopes.

2. A spiral-bound sketchbook to slip into a bag or pocket. Make sure it has a solid back.

3. A reasonable selection of cartridge paper. It ranges in tone from stark white through gray to warm cream. The texture can be satiny smooth or as rough as a plowed field. The smoother the texture, the less holding your paper will have. Soft pastels and charcoal will sit precariously on the surface, and will sometimes literally fall off and contaminate everything in the fall-out area. Very rough paper can trip you up and consume nibs and fracture pastels. This quality of paper would normally be stretched and worked over with a wet medium. Try to stick to the middle of the range; the extremes of rough and smooth are normally the province of the confirmed specialists.

4. Willow charcoal; the quality is often unpredictable but it lifts off easily.

5. Compressed charcoal. This is graded from hard to soft and is very black and dramatic.

6. White soft pastel for highlighting and editing.

7. Pencils, preferably B,3B,7B, which are at the soft end of the range. I find them more

BELOW
Viv Levy
Life-sized drawing made with a six-inch household brush and black and white emulsion.
You need to stand well back, use your whole arm and throw caution to the winds when wielding a decorating brush. The white paint is useful for obliterating mistakes, and a large roll of paper is essential, so that you can cut your surface to scale.

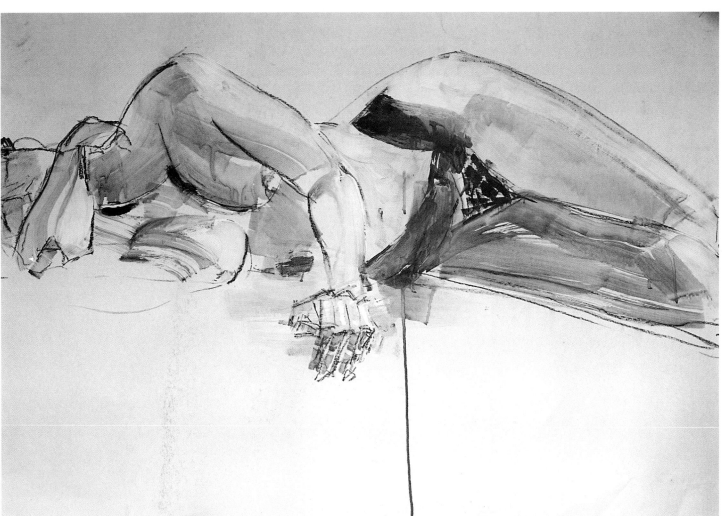

versatile and compassionate than the HB range, which is more suitable for the making of plans, maps and very accurate design work.

8. Black and white oil pastels. These are soluble in turpentine; you can produce interesting marks by laying down areas of oil or wax and washing over them with watercolor or ink.

9. Pen, nibs and ink.

10. A large putty eraser or a loaf of damp, sliced, white bread. The advantage of using pellets of bread to clean paper or to erase is that you have an endless clean supply. You will, however, have to contend with a mountain of carcinogenic crumbs and a pile of molding crusts.

11. Black and white household emulsion paint.

12. Small collection of brushes up to six inches, including cheap DIY variety.

13. Brown sticky tape for stretching paper. You do this by soaking the paper, laying it flat on a board and then sticking down all four sides with tape that has been run under the tap. By the time it has dried out the paper will be as tight as a drum and will take watercolor without bubbling.

14. Masking tape, for tacking down drawings, for masking off areas you want to leave white, or for achieving a hard edge.

15. Ozone friendly fixative spray.

16. Heavy-duty craft knife.

17. Fine-grained glass paper for shaping leads and graphite sticks.

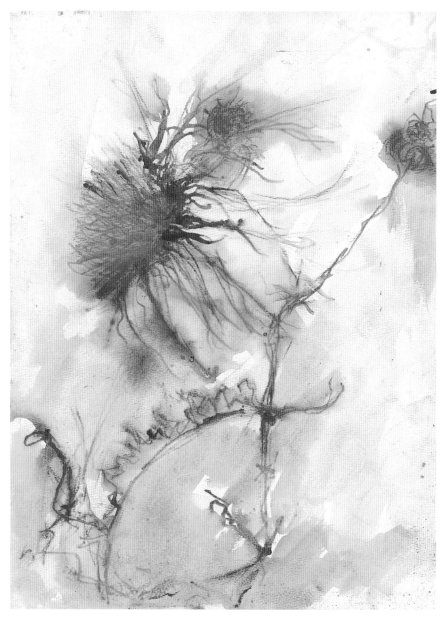

ABOVE
Viv Levy
Plant
Watercolor, applied with stick, pastel and wash, 12½ × 9¼ inches (32 × 23.7 cm)

LEFT
Viv Levy
Drawing, made with charcoal, pastel, black and white paint, sprayed with water and belabored with sandpaper and sponges, 72 × 48 inches (184.3 × 122.9 cm)
A kind of organized dictionary of marks, early morning exercise in loosening up and banishing inhibitions.

RIGHT TOP
Organized mark-making on a smaller scale: (top) ink and wash manipulated with both edges of a flat brush; (above) pigment and wax applied and manipulated with a palette knife.

18. A good-sized drawing board or a suitable substitute.

There are a million tools for free all around you: sticks, feathers, scraps of cloth and fingers (preferably yours). With a little ingenuity these can be transformed into efficient conveyors of ideas to paper.

The color you choose will depend on the subject you are looking at, whether you favor realism or a Fauvist flight into the imaginary. I used to lose control when I came across mouth-watering displays of colored materials. I have now, almost, managed to keep my hands off and buy only what is needed for the job in hand; over the years I have built up an awesome spectrum without going broke.

Making the First Mark

Nothing is more intimidating than a clean sheet of paper and a hoard of brand new materials. Break the spell and try everything out. You can learn to control the mark you make and to choose when to use it. Don't just accept the given point of a new pencil, tailor it to your needs. Expose the lead with a craft knife; a pencil sharpener will give you a universal point, excellent for applying make up or for drawing up plans, but useless if you want a varied subtly textured line. Don't be afraid of breaking charcoal to find a new line or of shaving it onto the surface to find another texture. See what happens when you spray the face of your drawing with water, how lines bleed, colors merge . . . Exploit accidents and do not allow them to paralyze you.

For your first project, make a dictionary of marks and annotate it. Try out every combination of the treasure trove of materials you have accumulated on as many sheets of paper as necessary: Chinese drawing ink swooshed onto tissue paper with a large brush; HB pencil missing the point on expensive hand-made watercolor paper; extra soft compressed charcoal dissolving and spreading, almost edible, on drenched newspaper; etc., etc.

Learn to enjoy your materials, not to fight with them. These are your potential allies. Find out about them, don't blame them retrospectively for your lack of judgment. Make your own index of possibilities.

BELOW
Dictionary of marks

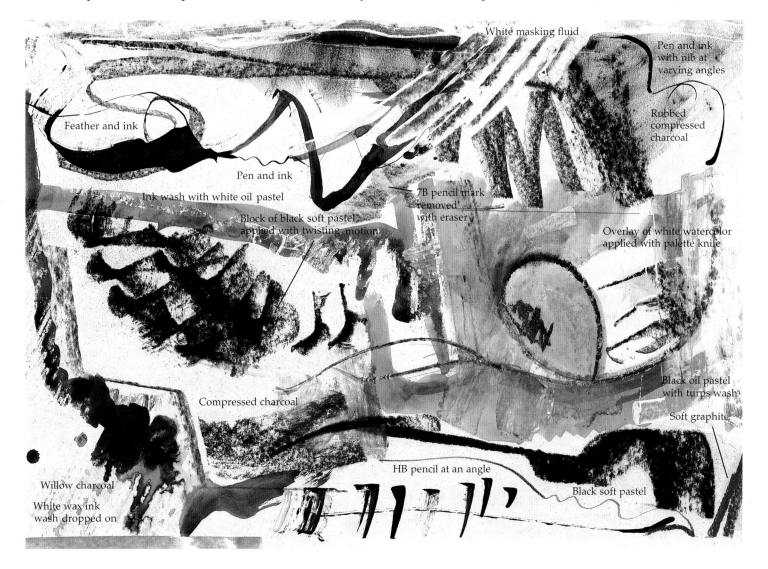

White masking fluid

Pen and ink with nib at varying angles

Feather and ink

Rubbed compressed charcoal

Pen and ink

Ink wash with white oil pastel

7B pencil mark removed with eraser

Block of black soft pastel applied with twisting motion

Overlay of white watercolor applied with palette knife

Compressed charcoal

Black oil pastel with turps wash

Soft graphite

Willow charcoal

White wax ink wash dropped on

HB pencil at an angle

Black soft pastel

3. Planning the Page

Placing the Figure on the Page

You have identified your model and the scene is set. You have rigged up a drawing board and fixed your paper to it, making sure that it is the right way up. Now plan the page, aiming to include the whole figure on the page. There are those who can never find a suitable piece of paper to accommodate their drawings. This is bad planning and if you allow it to happen, you will find yourself accepting compromises after the event. If you start out with the intention of drawing an enlarged detail, by all means do so, but if your original strategy was to draw the whole subject then plan the page accordingly; don't end up with a headless torso or minus the feet.

Aim to use the whole page, filling the space at your disposal; we will deal with the subtle stage management and manipulation of space once you are confident enough simply to draw what is in front of you.

Now spend time just looking and drawing in air. You may feel foolish gesticulating in a

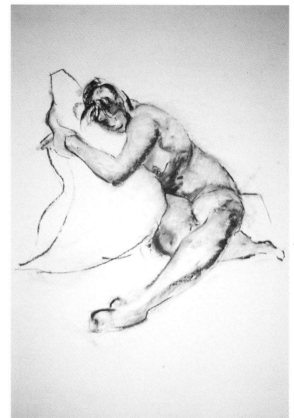

LEFT
Viv Levy
Model Clutching Cushion
Charcoal and pastel.
The model is firmly clamped to a huge cushion center page; the foot appears disproportionately large as it shoots forward toward me.

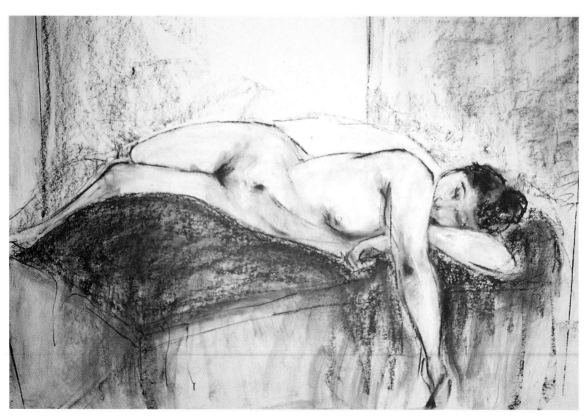

LEFT BELOW
Viv Levy
Model Asleep
Charcoal and pastel.
The bed she lies on and the verticals behind her are drawn in and operate as yardsticks to place her on the page. Get these right or they will send the whole drawing out of kilter.

TOP NEAR RIGHT
Viv Levy
Small Dog
8b pencil, 2⅜ × 4 inches (6.1 × 10.2 cm)
A very obvious example of someone who fits perfectly into a rectangle. I have isolated him in the middle of a landscape format to emphasize his lack of stature.

TOP FAR RIGHT
Viv Levy
Skeletal drawing 9½ × 12½ inches (24.3 × 32 cm)

RIGHT
Mike Winstone
Torso
Charcoal.
Deliberate study of part of the figure, planned to occupy the whole page.

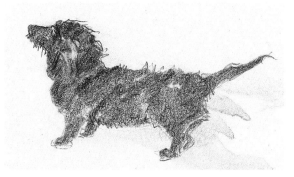

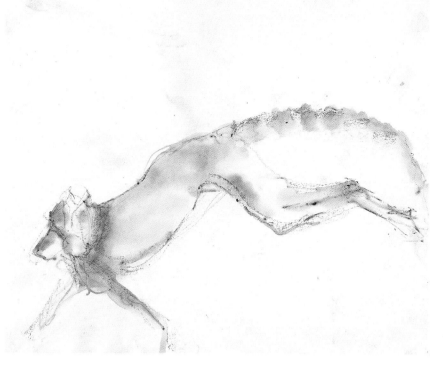

vacuum – this is what cameramen do when they are lining up a shot – but the practice run is a pause for thought, an opportunity to look again and to loosen up the arm. You may think you know your model very well, it may be someone you see every day, but over-familiarity really does breed contempt. Without looking again or resorting to generalizations, (he has eye like Paul Newman's, a silken coat), try to describe, in words, the subject you are about to draw. Write it down if it helps you to formulate your thoughts. Now look again and see how useful your description was. How much notice had you really taken? Our ultimate aim when drawing is to find visual metaphors to accurately and sparingly describe the model, but you must first make sure that your seeing is meticulous.

If you are in any doubt about the mechanics of the pose, walk around and look at different views until you are sure that you understand it.

Mapping the Figure

Are there any verticals or horizontals in the picture? If so, establish them on the page, if not, either use the edges of the paper as a guide, or draw a faint cross down the center of the page; you now have a device with which to judge all the diagonals. Visualize the overall shape which is going to contain your model, square, rectangle, triangle, oval or circle, and place it on the drawing, bearing in mind its relationship to the established verticals and horizontals. Find the center.

Plot the dynamics, the famous diagonals. It is rare for any living thing to slip naturally into a symmetrical pose or to grow vertically and conveniently toward the ceiling, sprouting branches at regular intervals. There will be a swing of the hips, a tilt of the head, a twist of the spine, a stretch toward the sun; look out for this.

By now you should have a rudimentary map and be out of danger of falling off the

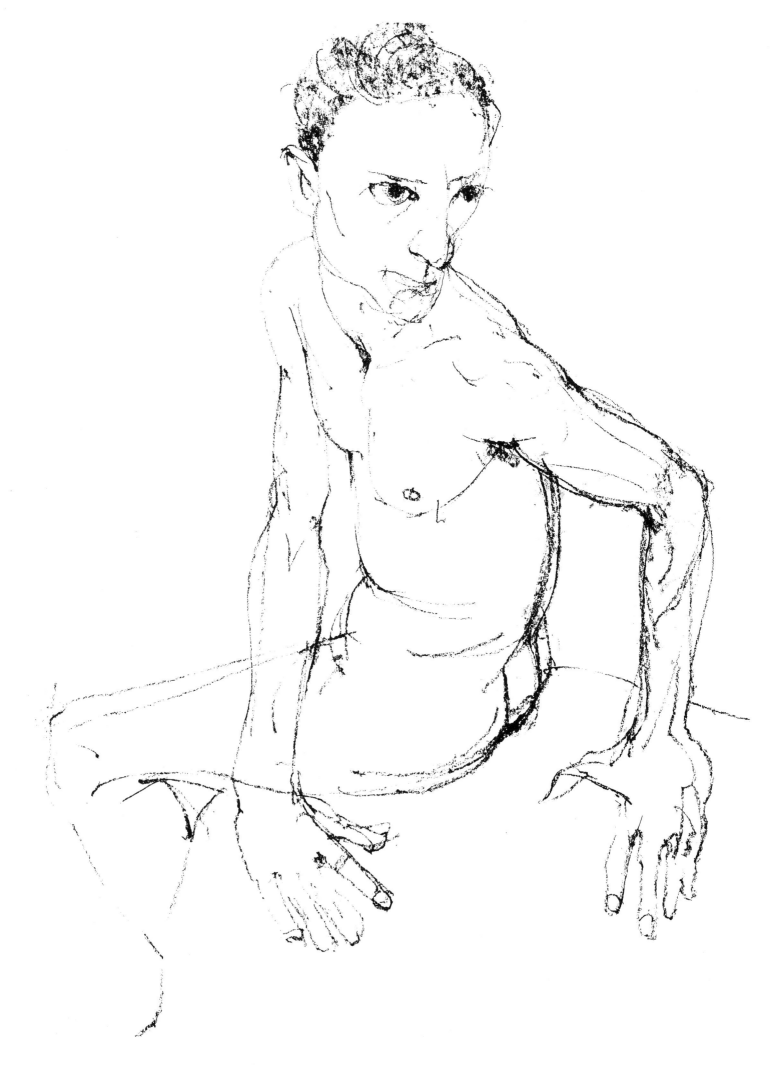

page or mislaying any limbs. Start plotting your way around your map. Look for useful reference points and punctuate the plan by placing the navel, the nipples, a bud, or any other strategically placed feature which will help you to see the way, checking their relative positions. Make sure that what you are seeing is physically possible; when in doubt, get into the pose yourself and feel your way around it. The spine of a human, or an animal, flows in a line from the skull to the coccyx, or the end of a tail; it cannot whizz around bends or break off mid-back to reappear behind an ear. The spine holds us up and cannot take leave of its moorings to wind up glued to a thigh or to the left or right of a shoulder blade. A front view has a center of gravity which is also governed by the position of the spine. Remember that one phenomenon affects another and you must be aware of the whole. If you are unable to see it from your view, get up, walk around and check it out.

The same general rules apply when you are tackling a plant. It will have a central stalk or trunk, branches reaching out at irregular intervals, buds pushing through, flowers emerging. Nothing is stuck on, everything is growing out of something else. Allow your drawing to grow in the same way. These are not dead things; look for their structure, keep them alive on the page.

Expanding Your Plan

Move, with a relaxed hand and arm, around your map, filling in information. Stand back from your work and make sure the proportions are correct. Don't at this stage get seduced by detail and decoration. You may be fascinated by a set of alluring eyelashes, an eccentric hairstyle or the tracery of veins, but resist the temptation to concentrate on them now. You may well be attaching them to absurdly spindly bodies, or using them as a good excuse not to include the feet.

Pin your subject down into context. There is always gravity; people and things do not float around in mid-air. Don't just plonk your model on the flat surface of the paper with no attempt to set him/her in space or to connect to the round. If your model is sitting, show us the seat of the chair, if standing indicate the floor. Shadows and reflections can also be exploited to establish your subject in the real world.

Don't be afraid of measuring. Unless your seeing is particularly acute, you can't always rely on instinct to get things right. Hold a pencil, or straight edge, at the end of an extended arm, at eye level. Don't bend your arm or change your eye level or you will get conflicting information. Close one eye and, with the tip of the pencil lined up with the item you want to check, slide your thumb up

FAR LEFT
Bryan Kneale
Aldo
Conté, 16¼ × 11½ inches
(41.6 × 29.4 cm)
The model is quite clearly twisting around his center of gravity; he is tense and about to explode into a pirouette. Aldo is a dancer; all this we read from a few well observed lines.

BELOW
Viv Levy
Lemon Geranium
8b pencil, 9½ × 14 inches
(24.3 × 35.8 cm)
Showing the gnarled growth scars on the branches and suggesting the veining on the leaves.

or down until you find the opposite edge of the item, as if you were operating a slide rule. Take this measurement and check it against another section of the drawing; is truth stranger than fiction? You KNOW that a greyhound has a long muzzle but if he is pointing at you, nose on, it APPEARS short. You are getting a foreshortened view which you may find difficult to believe. Don't confuse what you know with what you see. If you simply cannot accept a degree of foreshortening, measure and check it against something you do understand, the corner of a room or the line of a shelf.

To survive these preliminary stages, make lots of drawings on cheap paper. Don't get bogged down with a time-consuming masterpiece but try things out; you can't do everything at once. Don't take on the responsibility of expensive paper which you will be afraid to ruin; you are allowed to make mistakes as long as they are profitable. Pin your work up at the end of the day and try honestly to assess your virtues as well as your faults. Don't chuck things out, they may look different tomorrow.

LEFT
Viv Levy
Quince
Pencil, 8 × 5⅝ inches (20.5 × 14.4 cm)
In bed, drawing my dog on the bed. His nose, up close, protruding upside down from the duvet is as large as a paw waving in the air.

BELOW LEFT
Viv Levy
Nude Asleep

BELOW
Viv Levy
Hassid
Pencil, 9 × 6¼ inches (23 × 16 cm)

RIGHT
Dido Crosby
Movement
Pen and ink, 16¼ × 11½ inches (41.6 × 29.4 cm)

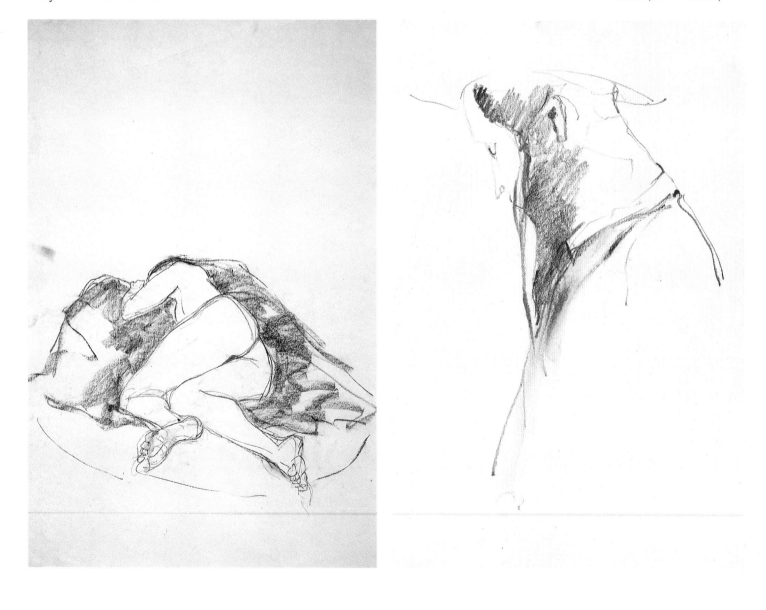

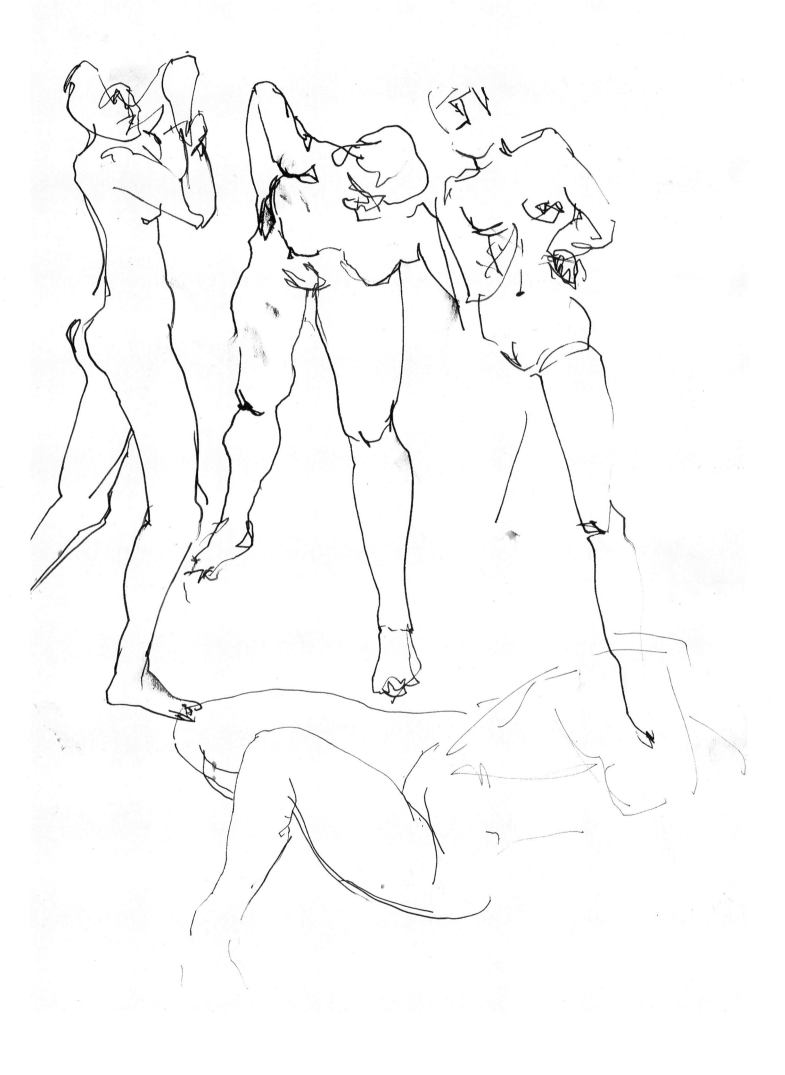

4. Believing the Evidence of Your Eyes

We often take perverse delight in making life more difficult for ourselves than it really is. Everything in this section may seem glaringly obvious, but it is very often the 'obvious' that holds the key to success. We ignore or overlook it as we rummage around looking for higher, more challenging fences to hurdle. The simple message is LOOK before you leap.

Your most valuable assets for drawing are your eyes. The importance of looking and believing in what you see cannot be overstressed. Seeing is your business; you must spend time looking and know what to look for. I am bombarded with excuses from students too impatient to stop and absorb this advice, as they stare, disbelieving and furious, at the fruits of their, very real, labors. There is something wrong with their spectacles, the light is bad, they have a blinding hangover, they find the model unsympathetic, they were being creative with the truth, they are living in a parallel universe.

You are at the beginning of a journey and your main concern should be recognizing and then avoiding bad habits. Your unique creativity, your need to make something more than a mere representation or decoration, and to include your emotions, will be fulfilled when you are less taken up with technical problems, when the co-ordination of your eyes, hands and brain is automatic. For the time being discipline is the byword to avoid disappointment and frustration. The mistakes you make early on in a drawing may seem insignificant at first, but unless you sort them out on the spot, if you try to get away with them, they will haunt the rest of the way and overwhelm the end

BELOW
Viv Levy
Reclining Nude
Charcoal and pastel.
This is a drawing that went wrong early on in the proceedings. In trying to salvage it I added layer upon layer of slightly off information. The result is overworked, overloaded and under-observed.

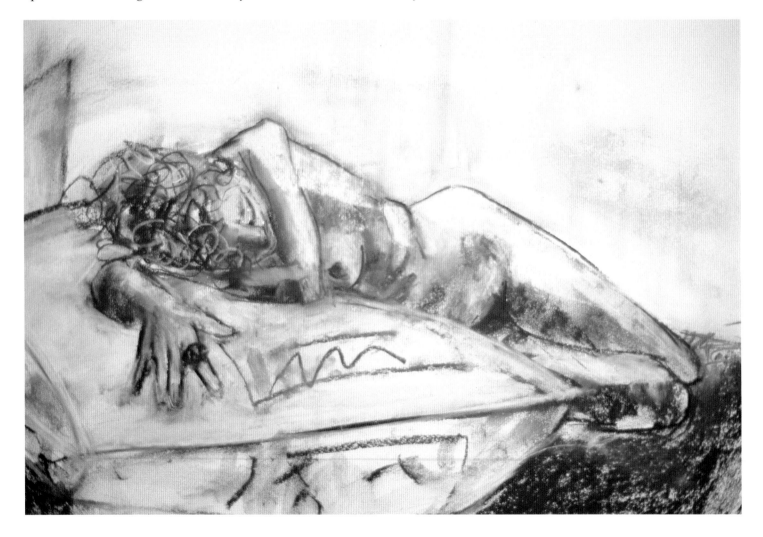

result. It is virtually impossible to pull off a convincing camouflage job if your looking was superficial and mistaken at the outset. The resulting drawing is a shambles of botched decisions. Do not accept approximations of the truth. We all have blind spots, but they have more to do with the inability of our brains to cope with the unwelcome surprises that our eyes have correctly registered. Holding on to images based on preconceptions is a form of indifference to that which is 'other'.

There are forms you may never have guessed at, let alone invented, until you start drawing. The more you draw, the more selective your vision will become. You will be able to identify the essence and edit the superfluous.

Try talking to yourself as you look; by explaining what you see you will make the subject more visible. Use your eyes and your mind's eye. Write down two or three observations about the model. Not 'it is green', 'it is big', 'she is beautiful'; although these statements may well be true, they are not specific enough to be of any use. Try variations on comments such as 'this person has a particularly long spine', 'the posture of a dancer', 'a quirky carriage of the head'. A

LEFT
Viv Levy
Plant
Pencil.
I managed better with this one by finding an appropriate shorthand to suggest the dense cluster of seed hanging on to an unlikely looking stalk.

BELOW
Bryan Kneale
Seated Nude
Conté.
Edited by eye, the lines on the page hit the spot first time. This level of confidence is only possible when the looking has been true, and when the brain and the hand automatically obey the eyes.

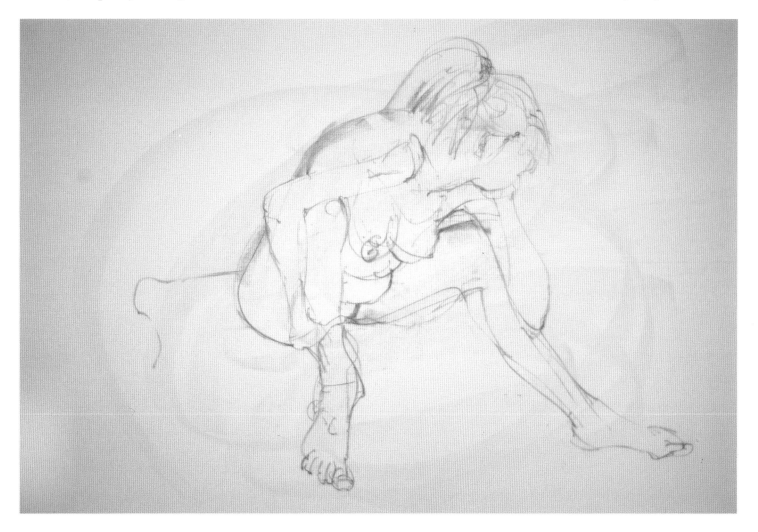

plant may have particularly dense foliage: how do you suggest this without painstakingly drawing each and every leaf? (Refer to your dictionary of marks.) Now make your drawing about the specific observations you have written down. Get your mind and your eyes working in tandem; this cooperation will clarify your vision and lead you to your next move.

Keep your critical faculties on red alert. If you find it hard to assess your own work, try looking at it in a mirror or turning it upside down; try anything to find a different view. Try masking a section of your drawing with your hand or with another sheet of paper. This will help you to isolate problems and to deal with them without the pleasant distraction of the bits you are impressed with; it is quite possible that the unmasking of the good bits will reveal a need for more drastic surgery.

There is a tradition in Japanese painting, a ritual that elegantly describes the attention you owe to your eyes and mind before you start. The paper is spread on the floor. The ink is calmly and slowly mixed in a bowl by your side, with a rythmic, circular movement of the hand and arm, a kind of meditation. The subject is contemplated, summoned into the head, imprinted on the mind. When it is ready it is projected on to the page. The loaded brush comes out of the bowl, the stroke begins outside the paper, continues through the drawing space and projects beyond. The result is a loose, confident, moving line: drawings as full of peace as they are suggestive of life.

Teaching Yourself to Look

There is an exercise to improve your ability to hold on to what you see for long enough to transfer it to the page. Look at the subject carefully and critically, both its overall form and the detail of individual parts, for as long as it takes you to think that you have memorized it. Then close your eyes and see it again, burned on to the inside of your eyelids, and hold it there. Imagine that your eyelids are cinema screens and your mind is playing on to them the image you have just shot. Open your eyes and project that image on to a piece of paper you have at the ready. Draw around the image and fill in as much detail as you can, and compare your drawing to the real thing; how close is it to the 'held' impression? If you are miles off the mark, this suggests you were not looking hard enough

LEFT
Dido Crosby
Studies at the Zoo
Pencil

BELOW
Utagawa Kunisada (1786-1865)
Preparatory sketch for *Genji* series

RIGHT
Dido Crosby
Standing Nudes
Pencil
Looking for the essentials of the pose.

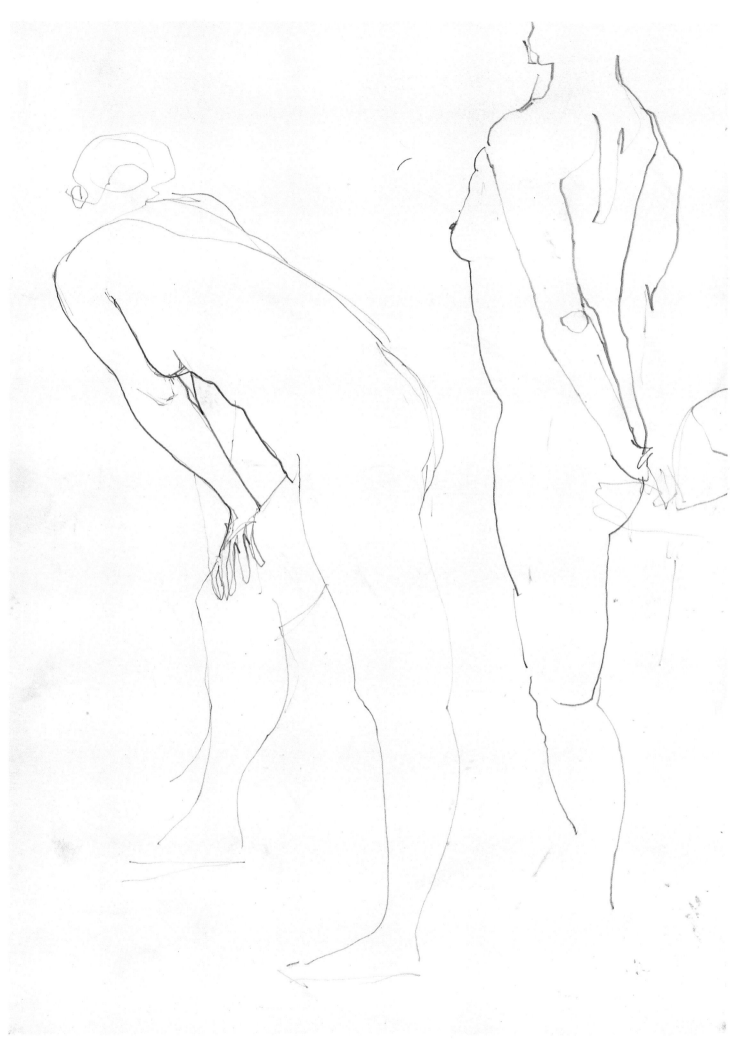

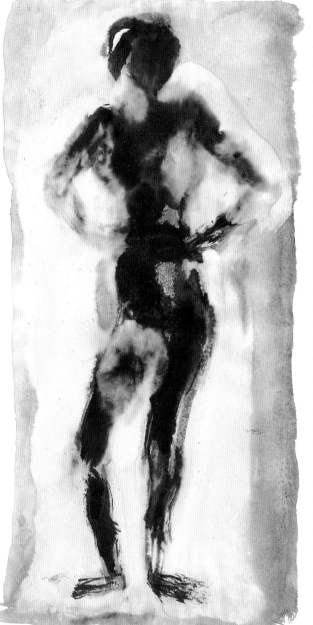

and you only registered a generalized blur in the first place. You need to train your eyes to see more clearly and your mind to absorb and retain more detail. Keep trying again until you begin to feel satisfied with the results.

Another way of testing the acuteness of your seeing and the extent of your concentration is to pretend that you are describing a close but absent friend to a stranger, and then to draw as you describe. Or pick the most familiar object in your life, something that you use or look at every day, and draw it from memory. Take the drawing to the object. How do they compare? Be critical of your performance; don't let yourself off lightly. Taking the easy path now will only undermine you in the long run.

By now you should be becoming aware of the lacunae in your looking, of how much you take for granted, the amount of vital in-

formation you miss even when you think you are in full command of your faculties.

I remain shameless about repeating the order to LOOK. Looking is a prerequisite to drawing, it shouldn't be a tedious grind. If you find it so, it is probably because you are bored with the subject matter, you have looked and seen nothing to persuade you to repeat the experience. If this is the case, accept it, change the pose or find something else to draw. Don't fear mistakes; as long as you learn to recognize them, and remember to avoid them next time, you will be winning. Train your eye to suspend judgment and disbelief. Your intuition and imagination will eventually come into play but they are not substitutes for looking. You are sure to have a few happy accidents to sweeten the pill; remember how they occurred and employ them to your advantage. Chance should be your friend.

ABOVE LEFT
John Dougill
Ink and bleach, 16¼ × 8 inches (41.6 × 20.5 cm)
This is all you need to know about the pose; hands on waist, swing of the hips, braced leg. Although the medium is unpredictable the artist hasn't panicked; he has tamed it and exploited the staining to tell all at speed.

ABOVE RIGHT
John Dougill
Wash on page of exercise book.
The figure lives and moves in two strokes of the brush.

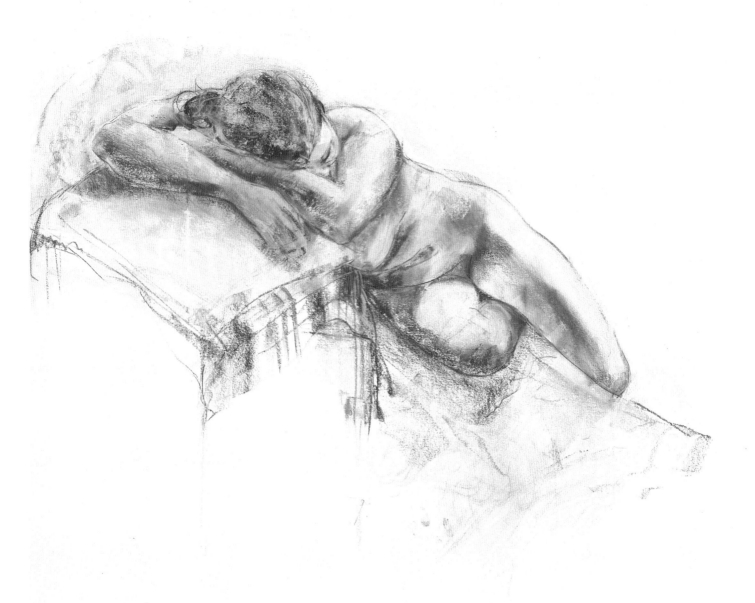

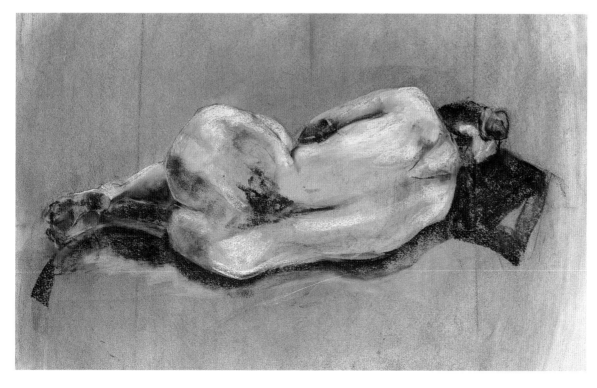

ABOVE
Viv Levy
Model with Cushion

LEFT
Viv Levy
Model Asleep

5. Exercises and Devices

Uses of Anatomy

You cannot operate by other people's rules. I believe that the time to resort to the anatomy manuals is when you know what you are looking for. Looking up a word in a dictionary is a huge problem if you are ignorant of the first letter.

The Renaissance was a time of change and discovery; artists were at the forefront of research into anatomy. Nowadays information is easy to come by. There are museums and medical establishments brimming with skeletons and flayed figures, there are publications like *Gray's Anatomy* (we all religiously purchased copies at art school and were so exhausted by the time we had carried them home that they remain unopened to this day). Take what you need, don't become saturated with facts that may hinder your seeing. Our external features often belie the underlying armatures. It would be neat if we could divide the world into species, learn the mechanics, flesh them out, and in so doing breathe life and individuality into our creations. Shades of Frankenstein. Don't rely on dispossessed theories. By all means read about proportion but don't accept other people's equations verbatim, check them out for yourselves; the proportion of classical form is true to experienced proportion.

'From the eyebrow to the junction of the lip with the chin, from the angle of the jaw to where the ear joins the temple, will be a perfect square.' – Leonardo

' . . . For our eye is cunning, and is learned without rule by long use, as little lads speak their vulgar tongue without grammar rules. But I gave him rules, and sufficient reason to note and observe: as that the little man's head being commonly as great as the tall man's, then of necessity the rest of the body must be the less in that same scantling. A little man hath also short legs and thighs in comparison to his bulk of body or head; but though the head be as great as the tall man's yet shall his form and face and countenance be far otherwise easy enough to discern. The tall man hath commonly low shoulders, long shanks, thighs, arms, hands and feet, wherewith our eye is so commonly acquainted that without rule to us known, it knoweth straight. But if an ill painter come which will make a child's head as little for his body as a tall man's (a child is but four times the length of his face, and a man ten times more) or his eye as little for his face as a man's, or his nose as great, I will not take

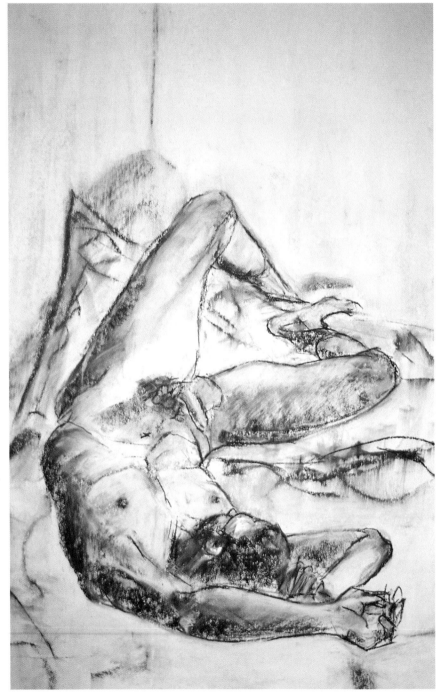

BELOW
Viv Levy
Charcoal and pastel
What is nearest is largest.

RIGHT
Dido Crosby
Model on the Move
Ink, 16¼ × 11½ inches (41.6 × 29.4 cm)
The easels remain constant, the model moves.

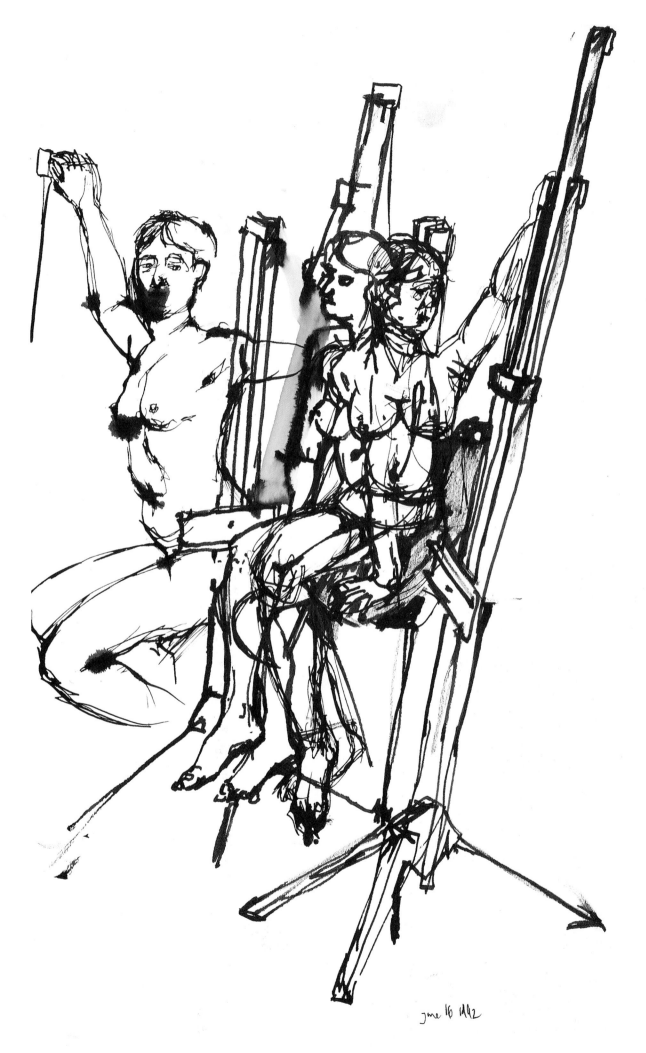

June 16 1992

upon me to know his tall man for a dwarf.' – Nicholas Hilliard

Well, there you are; some eminent advice for you to try out.

These exercises are designed to change your looking habits, to give you a framework to fall back on and a yardstick to measure up to. You will find that some of these devices will help you to achieve dramatic results but they are not a guaranteed recipe for the perfect drawing. Once you see how to render certain 'effects', you must be prepared to take risks and not just settle for the security of style.

The Model in Perspective The most sensible way to understand perspective is to remember that the thing closest to you is, comparatively, the largest. Look at the model and find the nearest point to you, then look for the point furthest away. Measure and compare. If you have chosen to tackle a foreshortened view, for instance a sitting pose with a foot stretched out at eye level, the underside of the big toe may appear to be as large as the head; measure and check and believe. 'What's nearest is largest'; allow this instruction to follow you around through all your drawings.

Exercise 1 Set up the subject matter or pose the model, then set up your drawing so that you will be working with your back to the subject. This will force you to make a conscious move to look long and hard in order to gather enough information to take to your drawing. It will stop you from snatching quick glances and from accepting approximate messages. Every time you need information you must turn your entire body

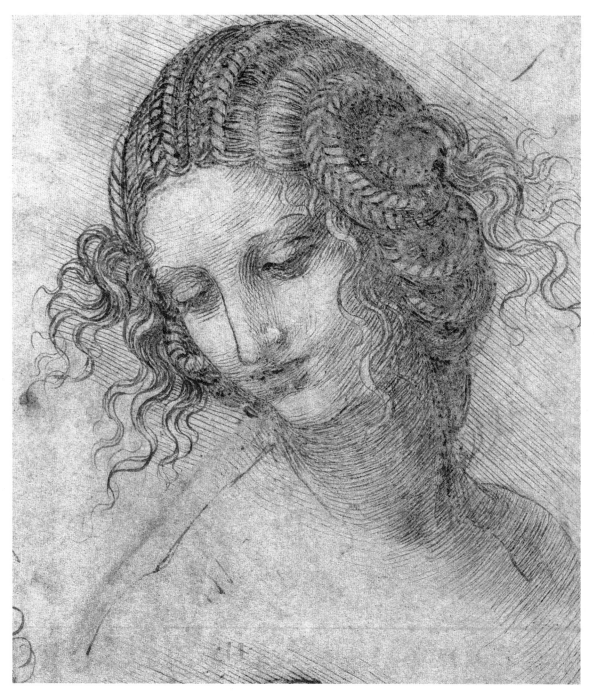

LEFT
School of Leonardo
Leda, c.1510
Red chalk, 10⅞ × 6⅞ inches (27.5 × 17 cm)
Look at the ways of tackling hair. You can almost feel the dense coils of thick hair in this exceptionally baroque coiffure, but the drawing remains uncluttered as it contrasts floating tendrils and ribbed plaits with the stillness and serenity of the face.

RIGHT
Leonardo da Vinci
Proportions of the Human Head
Silverpoint on blue prepared paper, 8¾ × 6 inches (21.3 × 15.3 cm)
Check this out for yourself. See how little space the features occupy in comparison to the rest of the head; take special note of the position of the ears.

around with a specific problem in mind, target that problem only, solve it, and take the answer back to the page. If you look for too much information at once, you will only retain a blurred impression of what you have seen. Your drawing will always tell you what to look for on the next turn. Resist cheating by angling for swift squints over your shoulder; you could put your neck out and will anyway be defeating the whole purpose of the exercise. The object is to force you to look, to teach you what to look for and never to accept nonchalantly the first thing you think you have seen.

Exercise 2 Make a set for your model to work in; by the way, you are allowed to turn around for this one. Make sure that your set includes a horizontal and a vertical. A large window, mirror or door frame will do, as long as you leave yourself enough room to distance yourself and get a good view of the whole picture. Draw the horizontal and the vertical, making sure they are properly placed on the page; these lines are your frame. Now look for the negative spaces between them and your model; the shapes that occur outside your subject, if they are accurately observed, will reveal the subject to you. This is a good ploy to capture moving figures; the inanimate components are constant reference points in a changing scene. Get your model to move every five minutes and draw the changing shapes that occur between the model and the frame. Work the drawings one on the top of another. Step back and see if you have made sense enough of the movement to reproduce the poses yourself.

Be prepared; this is going to be a long drawing. Make sure that your model is comfortable, that your animal is out for the count. You are to draw everything in the room but the model. The minute you encounter the silhouette of the subject, stop and go back to an adjacent portion of the room. Don't draw a line around the subject, it will appear of its own accord once you have dealt with everything else. You will end up with a ghostly presence; the empty space on your page will describe the model exactly, as long as you have accurately observed the containing landscape.

Both these exercises help to dispel the panic and fear that people often experience the first time they draw from life, simply by getting you to look elsewhere and allowing the figure to emerge, unbidden, out of the backdrop. Many students who are perfectly competent with structured objects give up in despair when they try to embrace and reproduce the human form. The planes, curves and angles of the body are beyond them because they are unable to perceive them with the same logical intelligence that they apply to something inanimate. Removing the anxiety factor is half the battle.

When I was a student I fractured my right hand, I felt very sorry for myself and assumed that I would automatically be 'hors de combat' until it healed. No such luck; I was ordered to stop wingeing forthwith and to use my left hand, which would not reproduce the ghastly misdemeanors of its mate. My first, reluctant and peevish attempts were shaky, tentative and highly embarrassing. Once I threw caution to the winds and gave up fighting, the bad habits programmed into the thinking hand vanished and the taste control switch flipped off, as I became preoccupied with finding a 'view' of the model that this unschooled hand could cope with. The goal, of course, is to get both halves of the brain working together, instinct and intellect conspiring to reveal all your talents. I now find that working with my left hand is a good trick to help me refocus, get me off automatic pilot, and shake and loosen me up when I have been concentrating very hard for too long and begun to fall back on habit rather than sight. Try it out; give the obedient hand a rest, the other one is a talented entertainer.

BELOW
Tiles on the kitchen floor; dog fitted on to the grid. Once you get the grid right you should be able to slot the image into it correctly, at speed.

RIGHT
David Annesley
Line drawing of dog made without looking at the paper, in one continuous line.

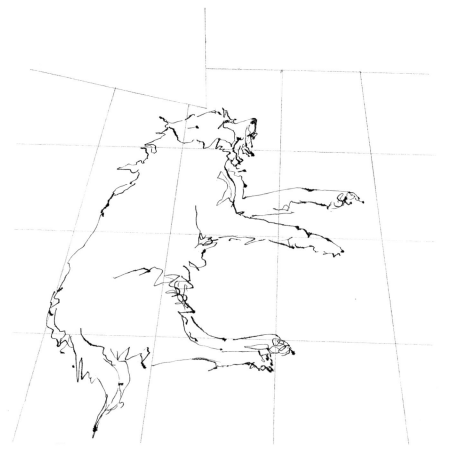

weapon. Your nose will now be effectively removed from the surface of your drawing; you will have a holistic rather than a close-up view and will be forced to use your whole arm, to make large, 'meant', marks to describe the model.

This is a technique that was once used in the theater, before the invention of projectors, to give an overview while painting backcloths. Huge drawings are impossible to visualize at close range. You can't be in two places at once, both the creator and the spectator, but by using a long-handled brush you can place yourself somewhere in the middle and find a vantage point to accommodate both appetites.

Exercise 3 There are always groans from my students, and a beeline for the nearest exit, when I announce the next project, but once you realize that it is possible and get stuck into it, you will begin to see why it was

Gaining Control

Now that both hands, your brain and two eyes are warmed up, it is time to get them all working simultaneously on some more challenging projects.

Exercise 1 The first time you try this choose something simple and symmetrical to draw; for example a standing pose, legs braced, arms relaxed at the sides. Using both hands, a pencil in each, two different colors if you wish, start at the top of the page with both leads poised at the same point, then, slowly, very slowly, draw them apart to caress the contours of the figure. Keep both hands moving all the time, don't jerk your way around the drawing but keep the movement slow and smooth. You will find that your hands want to mirror each other, and you will have to concentrate hard in order to get them to describe the two sides of the picture simultaneously: instinct and control working hand in hand.

Exercise 2 Another way to confuse control and to find a constant overview of your subject is to work at arm's length, to prescribe a distance from your drawing. Find a stick, a straight one, about three foot long, and attach a piece of charcoal to one end. Your position, from which you are not to veer, is at the other end of this long-handled

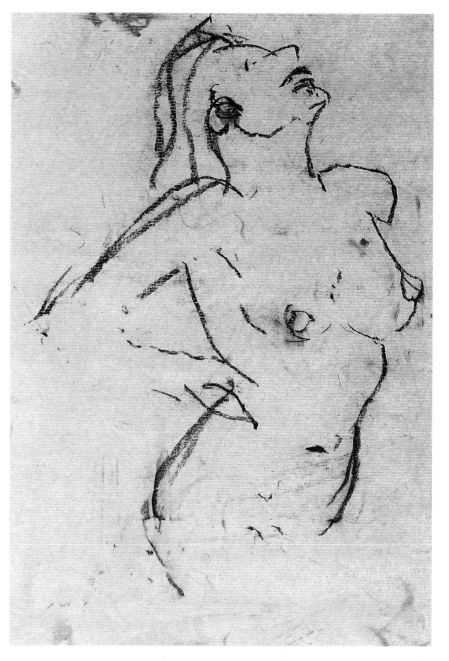

worth staying. You are about to draw the model upside down. I am not, for one moment suggesting that you should stand on your head, nor am I asking you to do a conventional drawing and reverse it later. Establish the floor at the top of the page, plant the feet firmly upon it and continue downward until you reach the head at the bottom of the drawing. This is not gratuitous torture; it is meant to persuade you that your eyes can reason. When you do, eventually, return the drawing to its formal stance, don't scream and make intemperate adjustments before you have compared it with the innocent 'right way up' world, and rationalized your former brain work.

Exercise 4 A terracotta sculpture is made by laying one roll of clay on top of another until you arrive at the completed, hollow, form. In order to predict the finished form you need to be able to think and visualize in cross-section. You have to be aware of three dimensions and to be able to understand the shapes through the center of a form. Try to imagine that you have taken a saw to your long-suffering model, and proceed to slice sections through him/her/it (i.e. through the head, from the tip of an ear, through the nose to the jaw, straight through the middle at the waist, or diagonally from shoulder to thigh). Draw these imaginary sections as though you were looking down on them. With these drawings in front of you, turn away from the model and reconstitute the pose from your notes.

Exercise 5 Here are a couple of devices to warm the hearts of the scientists among you. Firstly, how to make the perfect drawing, cold and correct. You will need a rectangular piece of card, roughly 9×5 inches. From the

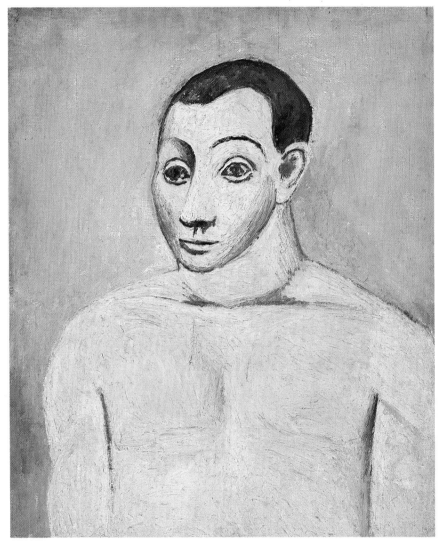

middle of this cut a smaller rectangle 4×3 inches, so that you are left with a substantial frame. The inside edges of this frame will correspond exactly to the size of your drawing; trace around them on to the paper. Divide and mark out these edges at half-inch intervals; the intervals on the card must match up precisely to those on the paper.

ABOVE
Picasso
Self-Portrait (1906)
Oil on canvas.
Unmistakably Picasso. He has made everything of his unique features and leaves us to believe the odd connection between neck and anonymous torso.

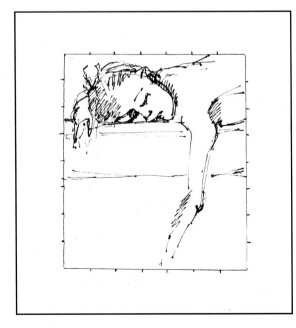

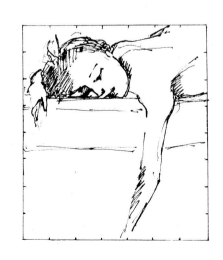

FAR LEFT
Cardboard frame to view through.

LEFT
Your drawing; same dimensions as the inside perimeter of frame.

Clip the cardboard frame to your drawing board, in alignment with the drawn rectangle and at eye-level, so that you are able to view the subject through it without writhing and squirming. Close one eye and focus through the frame as if it were the viewfinder of the camera. Using the corresponding measurements along the edges as reference points, fit the drawing into the frame; what you see is what you get, so stick to the rules and there will be no room for creative meanderings from the truth.

Exercise 6 For this you will have to draw out a grid on the floor. You may have a ready-made grid of carpet or lino tiles but if not, measure it out in masking tape. The squares should be about a foot square and the whole area should be large enough to accommodate the model lying flat out. Begin by drawing the grid without the model. This is more difficult, and will require much more time, than you may initially think, as you will be looking down on the grid at an angle and seeing it in perspective. Take the time to accomplish an accurate drawing, as this stage is crucial to the ultimate success of the exercise. When you have finished, ask your model to lie prone on the grid and superimpose this image on to your drawing, using the receding squares as a guide.

These two last exercises require a pragmatic approach; stay calm. I'm not an exponent of the cool measured drawing, I don't believe in seeing the model as part of the furniture, but I think it is important to prove to yourself that you are capable of seeing in a mechanical way, even if you dislike the computerized results. This sort of concentration is a way of tuning and honing the eye; the mechanical processes enable you to set visual traps, and give you a yardstick with which to study the enmeshed results and make sense of what you are looking at on paper.

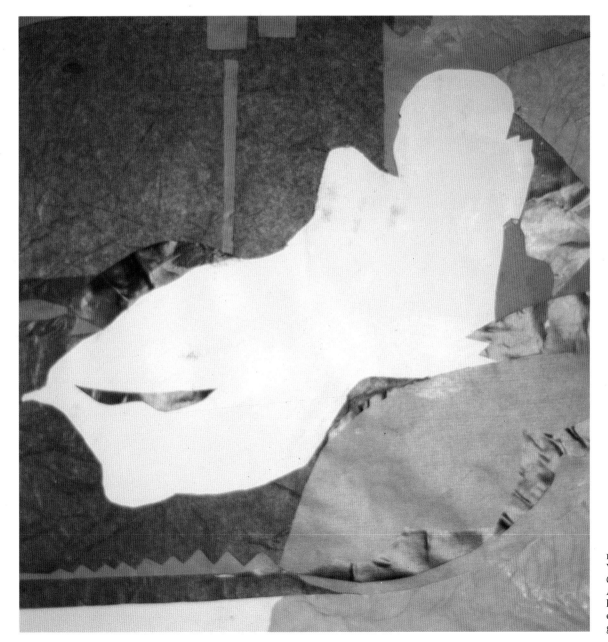

LEFT
Viv Levy
Collage
All the shapes around her led up to the model. She eventually appeared as a ghostly presence.

6. Line

'. . . The principal part of painting or drawing after the life consisteth in the truth of the line; as one sayeth in a place that he hath seen the picture of Her Majesty in four lines very like: meaning by four lines but the plain lines, as he might well have said in one line.'
– Nicholas Hilliard

'If a sculpture could be a line drawing, then speculate that a line drawing removed from its paper bond and viewed from the side would be a beautiful thing.'
– David Smith

The apparent speed and ease of the spare and eloquent line drawing should not be misinterpreted. Its simplicity is deceptive, and is certainly not synonymous with laziness or lack of time and concentration; on the contrary. You need to evolve a reductive technique and learn to edit with your eyes before you begin to draw, you need to grasp the essentials of the subject and to render them with economy, with line alone. Matisse talked of making drawings out of 'lightness and joy which never let anyone suspect the labor that they cost'.

Line does not have to be a sterile, constant mark, the boring track of the biro. You should already have found some rich and varied examples of line for your dictionary of

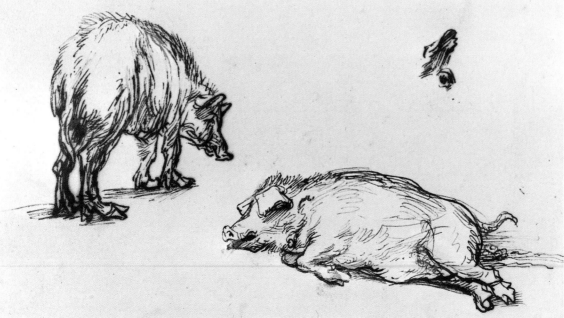

ABOVE
David Annesley
Self-Portrait
Graphite, 15½ × 11½ inches (39.7 × 29.4 cm)
Self portrait without the help of a mirror. This is an astonishing likeness.

LEFT
Rembrandt
Study of Two Pigs
Loose notation of a relatively small amount of information and yet the beasts are there, heavy, smelling of good earth and they make me smile in recognition.

LEFT
David Annesley
Plant Drawing
This was made without looking at the paper. As with his dog (page 37), you automatically understand and add the missing information; read between the lines.

BELOW LEFT AND RIGHT
Viv Levy
Postcard Home series
Small steel linear sculpture. Full frontal (left) and seen from the side (right). If only you could view drawings this way. Try some wire drawings.

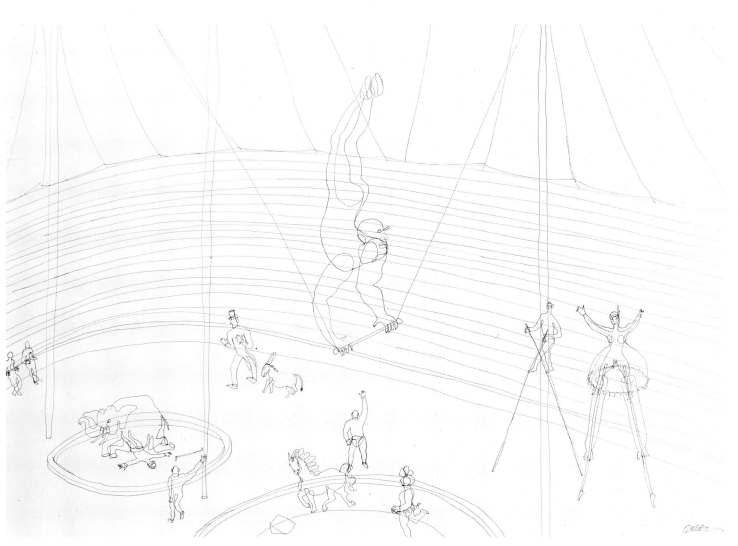

marks. Exploit a variety of materials and remain sensitive to their versatility. Think about what that glib phrase 'such a wonderful quality of line' really means. A line can be fragile or strong, pure and cold or sensual and loud, as long as it is pertinent to the character of the subject you are describing. Each line that you make should enhance and complement its neighbor and should not retrace or eradicate it. Your lines should sing; do not be tentative or stiff. Be prepared to make dramatic errors of judgment, and for your corrections and revisions to be exuberant and courageous; if a line is manifestly wrong the correction should be manifestly right, not a pale imitation of the mistake. Anxious scratchings and feeble stabbings, accompanied by vigorous rubbings out, do not lead to success.

A line is not a perimeter fence. It is not there to stop the insides from getting out, like skin; it is a device to make sense of what you are looking at on paper. Use it to delineate not to overstate. If you are trying to capture a moving figure, line is all you will have time for, with an eye like a camera on motor drive and the reactions of a young cat. Don't go back to recapture lost moments

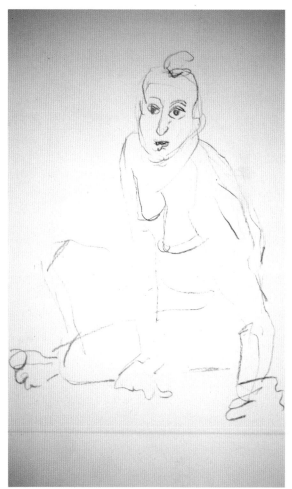

ABOVE
Alexander Calder
The Circus, 1932
Pen and ink, 20¼ × 29¼ inches (51.8 × 74.9 cm)
This is a drawing, not a photograph of a wire sculpture. Calder was able to perceive three dimensions, and express them with a single simple line as if he were holding the subject in his hand.

LEFT
Viv Levy
Self-Portrait
Charcoal.
Arctic conditions made speed an essential prerequisite to making this line drawing. It is sometimes beneficial to stack the odds against yourself: a good ruse to break bad habits.

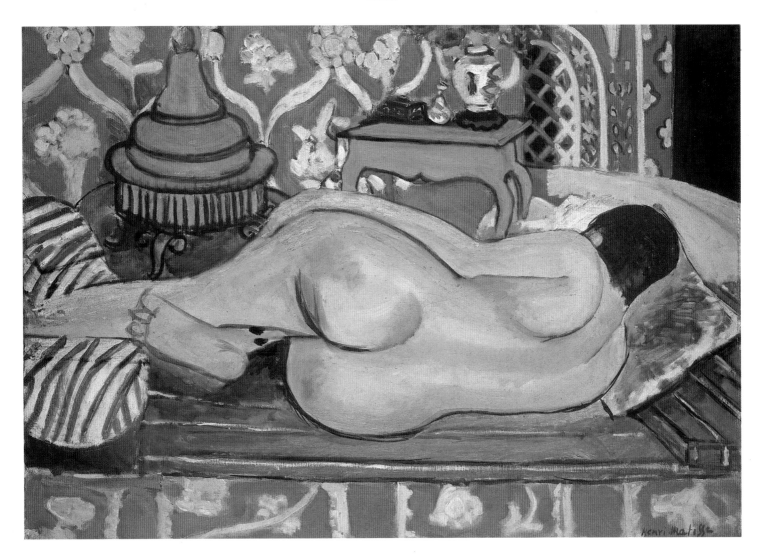

ABOVE
Henri Matisse
Reclining Nude, 1927
Oil on canvas
Matisse kept the drawing of
the model simple and
threw her into sharp relief
by painting in all the
decorative pattern, clutter
and color around her.

after the event; if you were alert enough, your original shorthand should be sufficient to say it all.

Exercise 1 Pick your subject. Stare at it. Now find your way around it with one continuous line without looking at the paper. Keep looking at the model, keep drawing; if the subject moves, take the line on the same journey. Don't even think about sneaking a look at the paper or you will immediately start to make value judgements and adjustments. You are trying to get a loose feel for moving line, not to make a pretty drawing. Only look when you feel that this part of the drawing is finished, and then you may see if there are any very slight additions you can make to render it more 'visible'. Punctuate the silhouette with just enough information to make it identifiable; don't get involved with detailing all the hairs on a head or a tracery of vessels on a leaf. The indication of a spine or placement of a central stalk will do.

Exercise 2 Close your eyes and think about how it feels to be inside your head, as if you were pushing out toward the skin. With your eyes shut draw a self-portrait. For information use a remembered image of your-

self and also use touch. Glide one hand over and around your face, draw the other one over the paper, draw what you feel in your body, use line, and don't panic about losing your place. Draw yourself full face and in profile. You will soon become familiar with the space on the page and to the sensation of being led by the line.

Alexander Calder made drawings exactly as if they were pieces of thin wire, as if he had flattened out his wire sculptures on the page. This exercise is greeted with rage and dismay: 'You're asking us to make sculpture and you're supposed to be teaching drawing.' David Smith described some of his linear sculptures as drawings in air. We are going to take a line for a walk into the third dimension, to get you to see that it is possible to 'speak' volume with line.

Exercise 3 Find a length of wire soft enough to manipulate in your hands and long enough to describe the figure in one line. You are not to make a matchstick person, animal or plant. This is not going to be an armature to be fleshed out with clay; the flesh will be implied with line. The line is going to pick up on the essentials of the pose, it is going to work backward and for-

ward through it (see cross-sections), and not just around it so that you end up with some sort of ill-advised gingerbread person. Don't rush; look carefully and find the best place to start. You only have one line and it has a long way to travel. Don't be over ambitious with the scale or you'll end up ensnared in yards of tangled steel and an overwhelming desire to reach for the pliers; pliers are banned. Aim to make a piece that sits happily in the hand. When it is finished use it as a guide to make a line drawing of the same

pose. With this three-dimensional aid you should be able to understand the subject from every view, including a view from above and below. Don't insert lines that you failed to see in the original but adapt the ones that are there; stretch them and manipulate them on the page until you have a see-through reversable image made of drawn line. You should be aware of transferring the plasticity of the wire into the line on the page.

For the last three drawings your line has

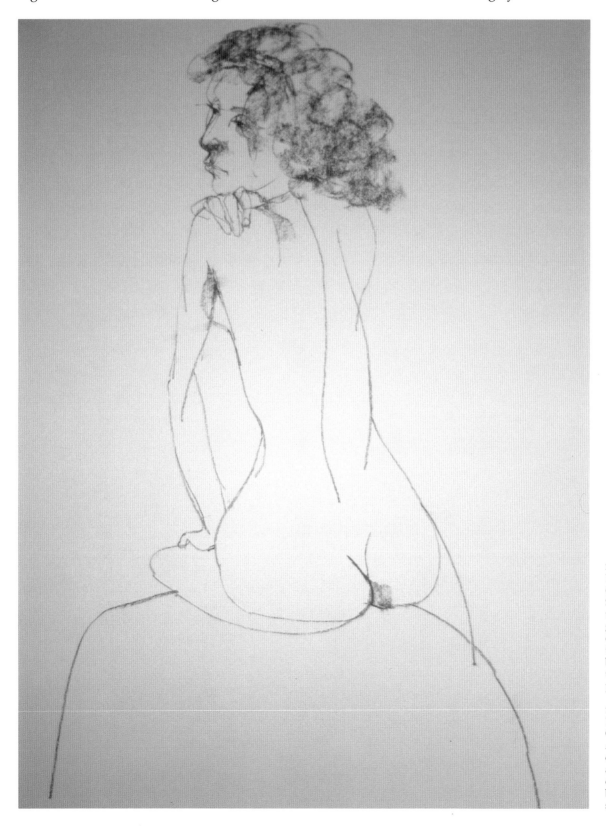

FAR LEFT
Egon Schiele
Crouching Nude, 1918
Schiele's models were usually skinny verging on gaunt, and he developed a cruel, brutal line to describe their ravaged faces and bodies. He was equally unsparing in his self-portraits.

LEFT
Bryan Kneale
Conté.
A wonderful, sensual use of a very slight line, topped and contrasted with a shock of hair where the conté has been turned and used on its side.

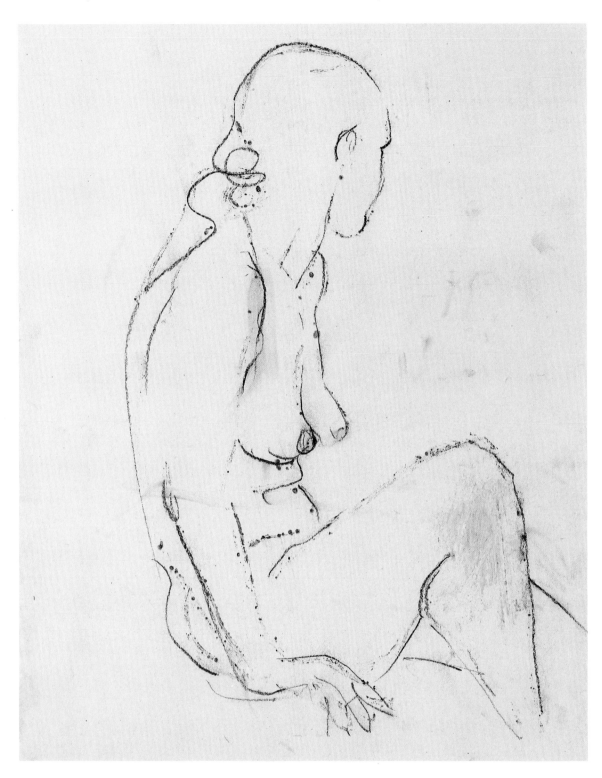

been 'given'; you have not been asked to be
inventive with the quality of a changing line
or to manipulate the section of a line. A line
can move from thick to thin, from light to
dark, from fast to slow. Start experimenting
with a brush of the soft, flexible, tapering,
Japanese drawing brush variety. Vary the
feel of the line by the amount of pressure
you exert or by changing the angle of the
brush. Use drawing ink or a thin wash of
color. Keep your touch light and your wrist
loose. Look carefully and aim accurately; the
medium is indelible and has an assertive
presence. Take the plunge and make the
drawing in a gesture. Be as theatrical as you

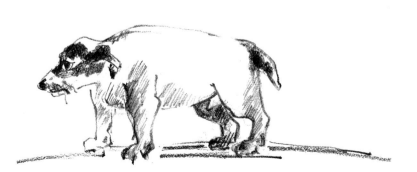

like, enjoy the freedom, the physical sensation, of the generous, live line. Make lots of these drawings on cheap newsprint until you feel you know the means and are able to surrender to them. You can be just as free with a line of charcoal or pastel, just remember not to accept prescribed marks dictated by the pristine point you found in the shop. Peel the paper off pastels so that you can reverse them on to their sides, shave or break charcoal until it gives you the line YOU want. If you are using pencil, expose a large expanse of lead on one face and use fine sandpaper to tailor the point to the required line. You should not be at the mercy of your materials; they are there to serve you. I often use sticks and splinters of wood instead of pens. I find them more versatile, as I can whittle or mash them into submission with no accompanying feelings of guilt.

It is very tempting to slip into caricature when you restrict yourself to drawing with line; to emphasize features without regard to the variety of the model. Try deliberately caricaturing the model: look for a feature, or features, to exaggerate, then do another version keeping what you originally saw under control and in proportion. There is a very fine dividing line between crude caricature and selective vision. Some people just can't resist crossing it; be sure of your motives.

The secret of a successful line drawing is in what you leave out. The frugal art of line is entirely pitiless. Enter into collaboration, a conspiracy, with the line and wait to see what the result will be.

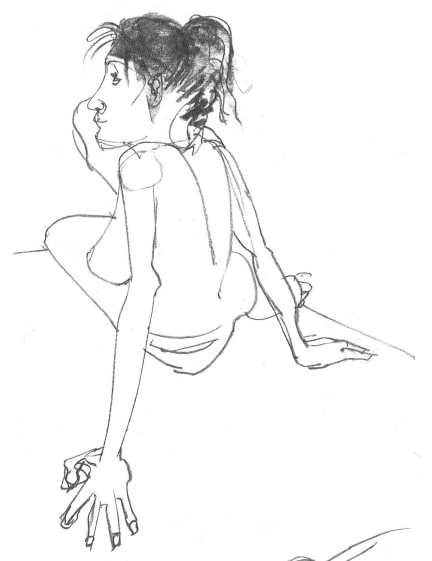

ABOVE
Bryan Kneale
Seated Nude
Conté, 16¼ × 11½ inches
(41.6 × 29.4 cm)
This borders on caricature but avoids it by a hair's breadth. The model was clearly relaxed but you can feel the drawing willing her not to move for just one second longer. You can read the relative speed of the line as it travels from the shoulder, around the hand in the foreground and back, to recommence down the spine.

7. Light

'The Light is either born here or, imprisoned, reigns here in freedom.'
– Inscription in the Archiepiscopal Chapel at Ravenna

Light is an essential prerequisite for seeing. Depending on the light source and the quality and quantity of light, form is either emphasized or flattened. Once you have grasped a simple logical system of understanding the laws of light and of investing a light source, you will have found a way of seeing that will enable you to understand and express form and mass.

All you need to know is that all surfaces perpendicular to a light source receive the same light value, while the more a surface is turned away from the light source the darker it becomes. Perspective and intensity of light work as well on a figure drawing as on a landscape.

Exercise 1 Having extolled the virtues of light, I am now going to ask you to make a drawing in the dark. If you have the means to black out a room during the hours of daylight, then do so, if not wait until darkness falls. As your eyes become accustomed to the dark, you will be able to discern your subject and can start to draw. Draw only what you are able to see, don't add prior information or rely on memory. As you progress you will be surprised at the extent of your seeing. Students complain that they are unable to see what they are doing to the page, let alone what is looming in the room. No bad thing; every decision you make will depend on your ability to force yourself to see; sloppy-looking invention or flashy decoration will not help. When you have plumbed the gloom for all it's worth, bring in one feeble light source. Start with one candle or the beam from a torch, and add information as it is relayed to you; gradually

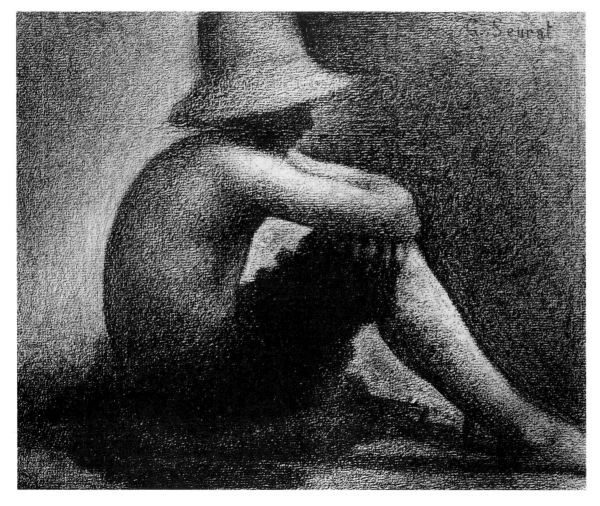

LEFT
Georges Seurat
Seated Boy with Straw Hat,
1882
Conté crayon, 9½ × 12¼
inches (24.3 × 31.4 cm)
There is no line in this
drawing; it is created out of
patterns of light.

TOP RIGHT
Viv Levy
Irises
Pencil and graphite, 9½ ×
14 inches (24.3 × 35.8 cm)
These were standing
against the window, backlit
and irresistible. The dark
and light were not
substitutes for color; they
were the actual tones I was
seeing.

bring up more and more light. The more the light reveals to you, the more you will add to your drawing. Carry on until you are satisfied that you have seen and recorded enough.

Exercise 2 This next exercise also involves moving from dark to light. This time, though, it is your page that is going to start off dark and you will find the subject by removing pigment from the surface, by seeing the light. Set up your subject in a raking light, from one strong source, so that you are seeing highly contrasting areas of light and dark. Scour your paper with soft charcoal or graphite – a roughish surface will hold the pigment – until you have an even black page. Look for the lightest areas of the picture and remove them with a putty eraser or a handful of breadcrumbs. When you have mapped out the lightest areas, find the black, if necessary pushing more black into the page. Let your eye travel across the

ABOVE
Viv Levy
Kristin
Black and white wax crayon and wash, 11¾ × 15½ inches (30.1 × 39.7 cm)
Painfully thin and obviously pregnant, she adopted me in Turkey and earned her keep by posing whenever the sketchbook appeared. I tried to flesh her out with light but liberal supplies of food.

forms from one extreme to another and start to pick out the mid-tones. With the eraser in one hand and charcoal in the other, add and subtract until the image coheres. Don't use line; ban it altogether from this drawing. The image you are creating may seem difficult to read to begin with; you may find it mind-numbing trying to find your way around the figure unaided by line. Persevere. Stick to a search for the play of light, the abstract shapes it makes, and the subject will appear as if by magic.

Exercise 3 Set up a pale figure against a black backdrop. Shine an intense light on the scene from one source, so that you have a dramatic area of contrasting tones to look at. Don't confuse tone with color; the darkest shadows on the white will be as intense and as dark as those on the black, as long as they are receiving the same amount of light. Make the drawing by looking for the dark, leaving the light to fend for itself. Draw the abstract shapes created by the shadows and don't draw lines around the white bits. Have faith; they will still be there if you spot them in time and resist interfering with them. Obey natural laws. Line is a means of conveying form to paper; nature does not rely on it to display its wonders. Light is a natural phenomenon; to understand it, imitate the way it works, see how it reveals and conceals.

Exercise 4 Choose an even flat light; the drama of this scene will come from you. Imagine that you have a strong light emanating from the end of your nose, and that this is the only light source. Hold this imaginary

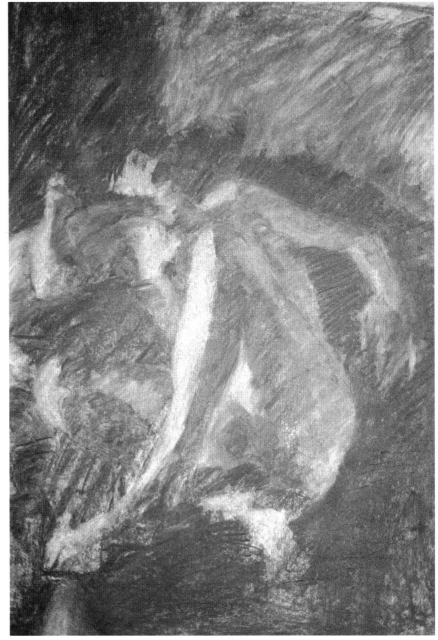

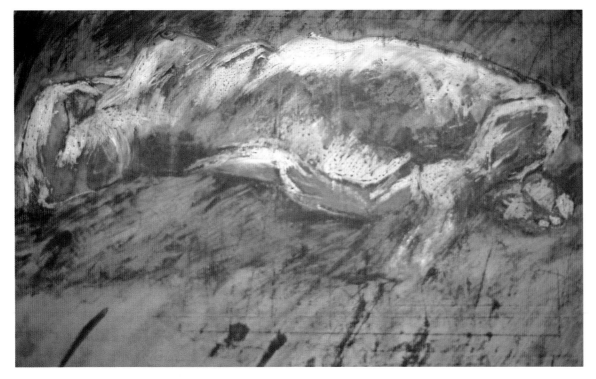

ABOVE
Viv Levy
Reclining Nude
Charcoal, removed and manipulated with bread. I started by dredging the page with charcoal and then found the patterns of light by removing the black pigment, and reapplying it when I was able to discern the semi-tones.

LEFT
Viv Levy
Reclining Nude
White oil crayon, black wash.
This was done the other way round. I found the light with white oil pastel on brown paper and then washed over it with a black ink wash.

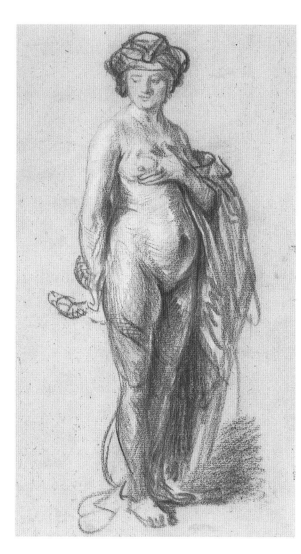

venetian blind, for instance. Block in the light stripes with white oil-based medium on white paper, then run a water-based wash of color over the whole drawing. The oil will reject the water and the light sections will become visible. You can cut out stencils to shine light through or paint patterns on glass; the patterns will automatically distort as they wrap themselves around the model. A faithful rendition of the distorted cast shadows will reveal the model for you.

For all the exercises in this section forget about underdrawing in pencil; learn to see without line, instead see directly with blocks of tone. Once you have gained confidence, start to complicate the issue with several light sources at once. Set up reflective surfaces and create distortions with crumpled cooking foil, cellophane, glass and a mirror. Try combining techniques, wet and dry media, adding and lifting pigment; don't get stuck with one way of tackling a drawing, every problem requires a different solution.

LEFT
Rembrandt, 1606-69
Study of a Nude Woman as Cleopatra
The light source is very clear; forms are revealed as they turn away from the light and become darker.

BELOW
Caravaggio (1573-1610)
The Conversion of St Paul
A magical painting in S Maria del Popolo, Rome. You apprehend it in a gloomy corner of a dark church. Out of the penumbra comes the light from this work. The longer you stare into the depths of this painting, the more you see; it is a literal conversion from darkness into light. The narrative is reinforced by the technique.

light source in your mind and shine it on the subject. Everything perpendicular to it will be receiving the most light, while as the forms turn away from you and the end of your nose, the less light will they receive. Work your way around the figure, separating out each form; the light will be playing the same tune across a wide expanse of thigh as over the small area of an eyelid. You are not recording what you see, you are imposing an imaginary light on to what you are seeing and recording that, so don't confuse the actual lighting in the room with the one you are projecting; if you do, the two sources will give you conflicting information. Try this out again and again with different imaginary light sources; light your subject, in your mind, from the left, from the right, from above, from below, from behind. Watch out for halo effects, back lighting, and reflected light, when a mirror or reflective surface is bouncing light back or refracting it. Assess the success of your imaginary lighting by rigging it up for real and checking your drawing against it.

Exercises Time to have some fun with wax crayons and oil pastel. Set up the subject so that it receives patterns of light; through a

8. Sculptural Drawings: The Clothed Figure

A friend was recently describing her first term at art school. For the entire twelve weeks, students were asked, or ordered, to draw a sphere, a pyramid and a square box until their vision was honed and their hands understood. They were not allowed near a plant or an animal, let alone a human model, until they had proved their profficiency at decoding basic principals. You need a high boredom threshold to keep reinvesting three structures and to find new ways each day of interpreting and seeing them. These days none but the brave would dream of instituting such torments into a drawing program, but I do see the point and tell the tale to underline, yet again, the importance of seeing the same subject matter in different ways. The man who taught me to draw still starts students off by getting them to draw a perfect circle freehand; we then had to find a way of turning it into a sphere and finally to place it firmly on the ground. From a flat, floating, graphic image to a grounded, three-dimensional form in three moves.

Sculptor's drawings are not always blueprints for the three-dimensional versions in bronze or stone. People are surprised at the flatness of some sculptor's drawings. Rodin, for example, created the illusion of space with a few lines. His drawings were ideas to be taken to sculpture, not plans to be slavishly remade. In this section I want to deal with sculptural drawings, not drawings for sculpture, to trick the brain into thinking 'stone', 'clay' on to the page.

Sculptural Drawings

Exercise 1 Imagine that you are carving the figure from the page. The page represents one face of a block of stone, and you are going to work through from the front of the block and release the figure within. Set up a dynamic pose and select an imaginary block of stone; it must be the right shape to accommodate the figure, who is already sitting inside it waiting to be chipped out. Your page is now the solid face of a lump of granite, and you cannot take off into its heart until you have chiseled out the features that sit

nearest to the surface. If the tip of a toe is the nearest thing to you, pushing at the surface, draw this first, but do not assume that the foot and the leg are the next logical things to be carved out. It could be that the knee has been pushed into the foreground, is hovering above that toe, waiting for release, so draw the knee next. Think of pushing your body through a sheet of glass, think about the sequence of features arriving on the other side, draw them as they arrive. By now you will have become aware of the dangers of putting in too much too soon. You may need to go back and mentally reconstruct the choreography of the piece. Beware of think-

Face of the stone

From the front, start with this point

Then these points, and so on

LEFT
You are on the right of the vertical line. You are viewing the model from the front. Imagine sliding the line backward and drawing each element as it pushes through the line.

RIGHT
Viv Levy
Sleeping Nude
Charcoal and white pastel. This drawing was made according to the principles outlined in Exercise 1 (left).

FAR RIGHT
Michelangelo
The Awakening Slave, 1520-23
Marble, height 97½ inches (250 cm)
The figure enslaved in the stone was released from the front of the block. Had you been treating a drawing in this way, the knee would have been your starting point (nearest to the face of the stone). Here the sculpture is trapped forever, in keeping with the subject matter, but you believe in the figure as a whole.

ing one way and acting in another. Each event in this drawing must be rationalized; there are no short cuts. You should have the sensation of drawing with the palms of your hands; they are skimming the surface to find the first protrusions, and wrapping around them to find the rest of the form as it shrinks into the depths. Allow the material, stone, to dictate your thinking; journey from the physical to the conceptual; apprehend weight and form on the page.

Exercise 2 Get your hands around a lump of clay or plasticine and make a small sculpture of the subject; be aware of pushing shape against shape to swell the clay into a hand-sized unity. Remember that you are dealing with reality, not illusion, so you must walk around the model to see the pose in the round. Ask your model to start with a sitting pose; make the sculpture; ask the model to stand, and stand your sculpture up without any plastic surgery. Now return to the first pose and draw it in the same spirit, with the same fingers that manipulated the clay. Go back to the standing pose and superimpose it on to the sitting figure in your drawing. Are you communicating and making sense, could your drawing walk off the page, is the illusion you have made as present and capable of life as the sculpture? Do you feel that you could hold the figure in the drawing in your hand?

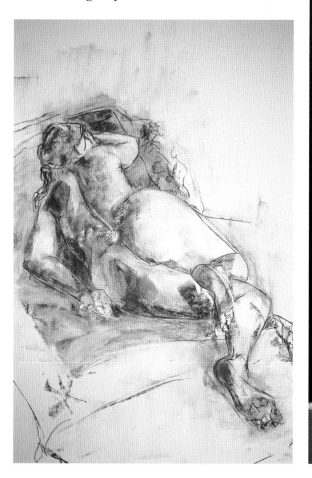

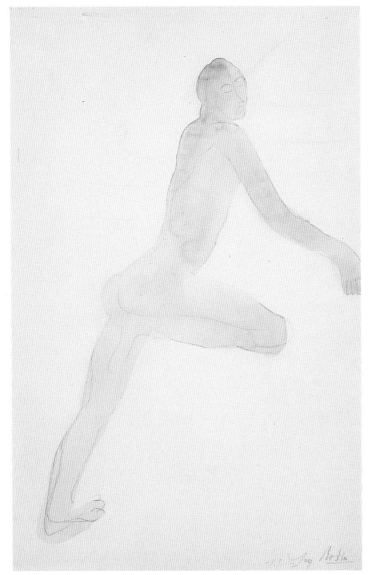

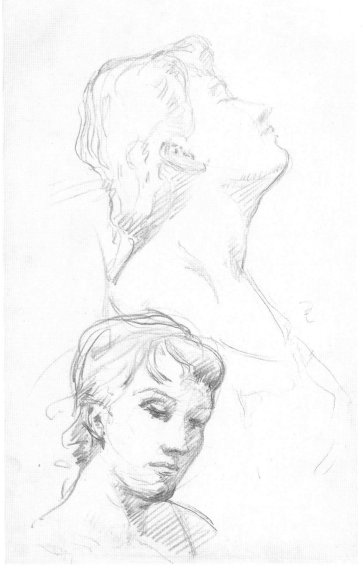

ABOVE LEFT
Auguste Rodin
The Rising Sun, c.1900-05
Graphite and watercolor on
cream wove paper, 19 ×
12⅜ inches (48.4 × 31.7 cm)

ABOVE
Adrian Montford
Heads
Red chalk, 16 × 10 inches
(40.9 × 25.6 cm)
Another sculptor's
drawing: economical,
modeled, serene.

LEFT
Viv Levy
Sleeping Nude
Charcoal, wax and wash, 36
× 48 inches (92.1 × 122.9
cm)

RIGHT
Auguste Rodin
Kneeling Girl
Graphite with watercolor
on white paper, laid down,
12¾ × 9⅝ inches (32.6 ×
24.7 cm)

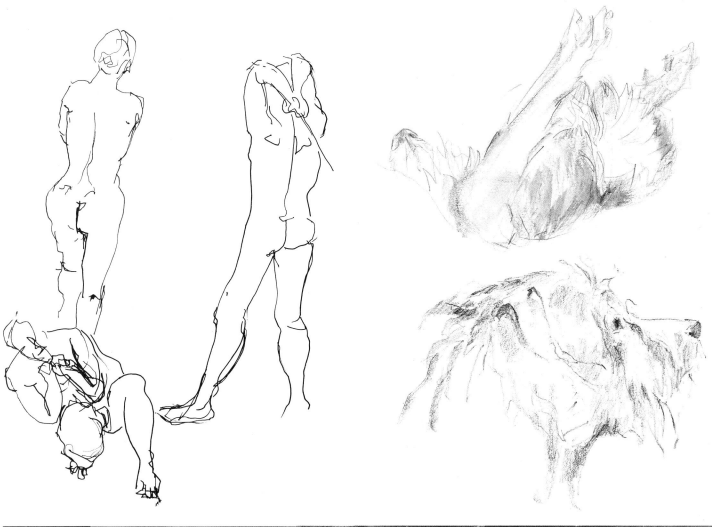

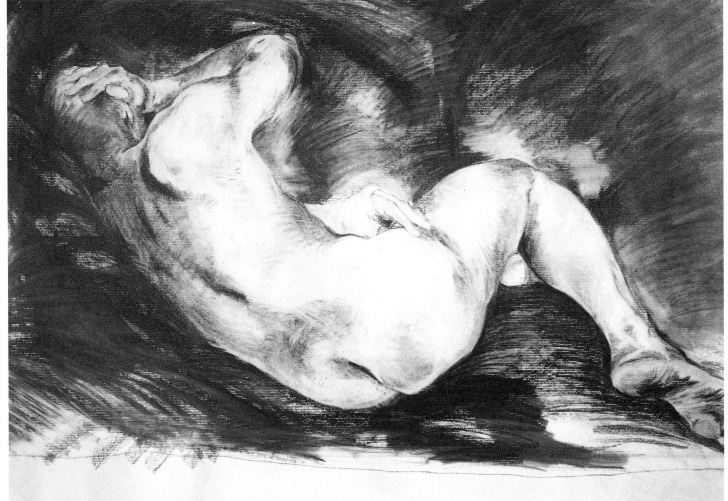

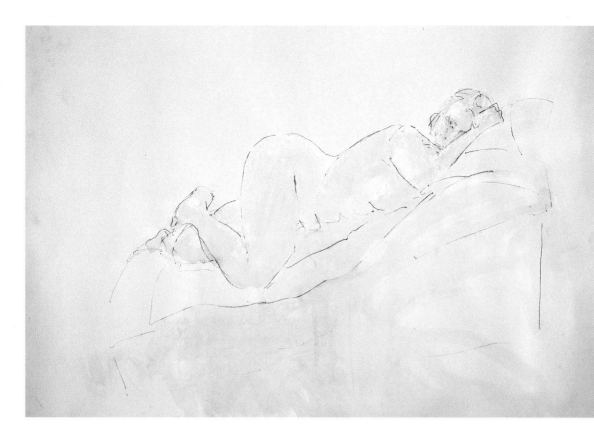

FAR LEFT
Dido Crosby
Moving Model

CENTER LEFT
Viv Levy
Quince Relaxing on the Bed
Pencil

BELOW LEFT
Nicola Hicks
Model in a Darkening Room
Charcoal, 36 × 48 inches
(92.1 × 122.9 cm)

LEFT
Viv Levy
Sleeping Nude
Charcoal, wax and wash, 36
× 48 inches (92.1 × 122.9
cm)

BELOW
Leonardo da Vinci
*Study for the Drapery of a
Figure Kneeling to the Left,*
c.1506
Leonardo is using the
drapery to describe the
solid flesh beneath.

The Clothed Figure

Making coherent representations of form when you are able to see it is difficult enough, but discerning it and making it visible when it is clothed can be a nightmare. A common mistake is to draw the clothes but not the body, to end up with a cardboard cut-out, a symbol similar to the MALE/ FEMALE signs on lavatory doors. Items of clothing may look identical on the hanger but once they are fleshed out seams strain, waistlines pucker, hems undulate. An apparently shapeless sack, cunningly draped and belted, can cause havoc with your perception, fool you into seeing goddesses where angels fear to tread. Don't be deceived; if you grabbed a designer jacket and trousers and stuffed them full of old newspapers, you might scare the crows or create a limp marionette but your acquaintance with 'life' would be questionable. Clothes are not an excuse for sloppy drawing. I have seen too many drawings of empty frocks with frantic legs tacked on to the hems, astonished heads glued onto collars, disembodied hands dangling from sleeves.

Exercise 1 Ask your model to wear a clinging garment, a leotard or a swimsuit. Begin by drawing the garment, paying special attention to the shapes created where cloth and flesh meet. Unless your model has had an unfortunate encounter with a steam roller you will encounter no straight lines. Now flesh out the garment; search for light

and shadow across the surface and see how the line changes as it moves from fabric to skin. In the same pose, draw the model nude and see if the information coincides. Try the same ploy with loose drapery. Use it to illuminate the body beneath, not to veil it. Exploit the drapery to enhance and underline form, examine the different textures of cloth and skin (use your dictionary of marks).

Exercise 2 Draw someone dressed in horizontal stripes, slavishly follow the stripes around the form. Stripes are a merciless banner, they accentuate every lump and bump, proclaim every twist, turn and swing of the body beneath. Make sure that you don't lose your head and flatten out the protruding bare limbs in grateful relief.

Fur and feather play uncanny tricks. You cannot, of course, pluck the canary, shave the dog or depilate the cat, but you can stroke them and feel through the thatch to the creature beneath. Look for the places where the fur swirls and hair parts, how

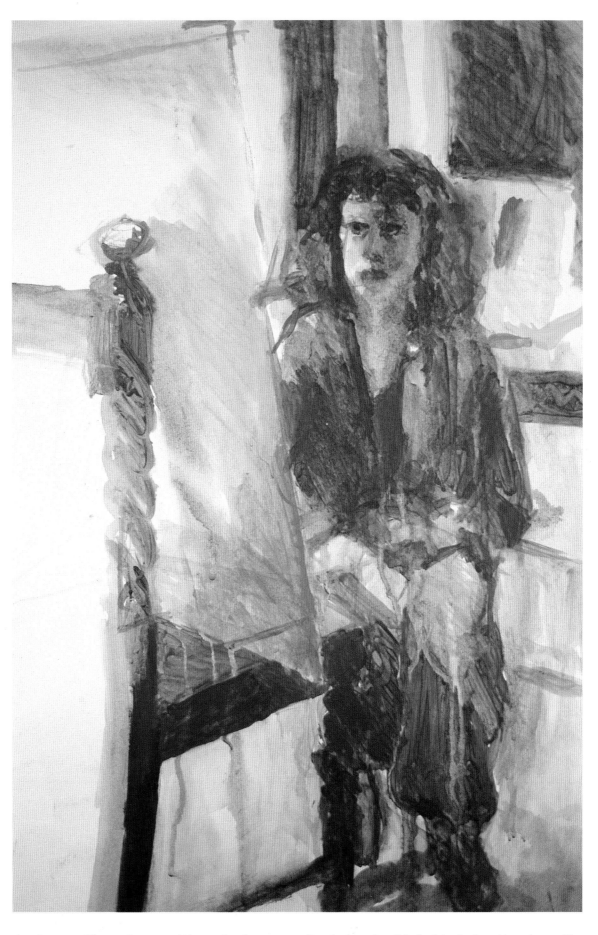

feathers ruffle and wings lift, make features of what you can clearly see and follow them through to the tip of a tail or the nakedness of a nose or a beak.

Plants and fungi dress themselves in fluff and filament, in bark, barbs and spines. Look for the life behind the disguises. Experimenting with clay will help you; you will discover how difficult it is to attach spines to a handful of air. Once you have grasped the underlying form you will be able to make an intelligent drawing of the carapace.

9. Color

'A color must be more than a color'
 – Max Weber
'Color adds another challenge. And I don't like pretty colors. I like kind of raw colors.'
 – David Smith

Up until now we have been dealing in black and white, with a monochromatic universe, ignoring the fact that the world around us is drenched in color. You will have to rethink your looking again, sweep away incidental information to make room for emotive, tangible, edible, glorious color. Don't think of color as the enemy; imagine picking up 'orange' and feeling that you could sink your teeth into it, sense the orangeness breaking on your tongue. Drown in the depths of blue, flinch at a scarlet, sigh in the presence of green, and then be prepared for a shock when you allow these colors to co-exist and play havoc with your emotions. A color can drain the life out of its neighbor or encourage it to sing. Gray can freeze the blood or persuade a minute blob of yellow to zing off the page. There are color wheels and color theories, color consultants and purveyors of good taste, but don't be blinded by science; the only way to learn about color is to use it. Don't think of color as something to fill in with, pick it up and use it directly as if you could hold it in your hand. Be expansive and generous, don't use blue, use BLUE.

I see no conflict between drawing and color, but you must sort out your priorities before you start using it or you will end up in a demoralizing, muddy mess. Are you aiming to reproduce, as faithfully as possible, the color in front of you? Or are you going to use color as a free idea, as metaphor, to trick the eye around the picture plane, as a vehicle for your imagination? The medium you choose will be incidental to the color. The vibrancy and transparency of watercolor is always tempting, but if you haven't used it before you may find handling it inhibiting. Whatever the medium, try out the colors on a separate sheet of paper before you start. Diluted color never yields up the promise of neat pigment, the identifying labels are misleading. The ratio of pigment to binder will affect the depth and consistency of color: soft pastels will deposit a much more intense

LEFT
Viv Levy
Nude on a Rainbow Quilt
Pastel.
Using color and pattern to 'find' the model.

color than their harder counterparts, which contain a higher ratio of gum arabic.

Banish the clutter, purge the mind. Rig up a situation draped with cloths of many colors, as bright and as outrageous as possible. Don't be afraid of breaching the bounds of good taste; leave the safe haven of fashion and have some fun setting up a wild colorscape. In the middle of it place the subject, your focal point.

Exercise 1 Your first drawing is to be a study of the color in front of you. Don't start with underdrawing; this is an exercise in working directly with color, so let the color guide you. You may be lucky and instinctively pick up, or mix, a perfect match first time, but if not take your palette to the subject and compare them. Try not to accept compromises as one color dramatically affects another and an 'off' one will turn all the others. Remember that there is no such thing as flesh color; flesh tones vary as much as the shape of a nose and change as they move across the body with the play of light. Don't deplete a faithful study of colored cloth by plonking a shocking pink nude in its midst, or by daubing your model with the contents of the magic tube marked 'flesh'. You may KNOW that a length of cloth is red; it has been evenly dyed and you think of it as a solid color. What you are SEEING, however, is creased red, draped and folded red, red reflecting and deflecting light. There are blues in there, purples and whites. It is as important to banish preconceptions about color and to see it all over again every time you look at it as it is to be able to see foreshortening and understand illusion.

This is a straightforward exercise, but there are no short cuts to success, you need to spend a lot of time understanding the subtleties of the apparently bright and crude colors in front of you. When you are starting out you will inevitably find that you are short of colors with which to mix all the permutations of tone you are discovering. Make a dictionary of color, companion to the compilation of marks you drew earlier. This will save you time, frustration and expense; you will be able to spot the missing links at a glance and avoid purchases based on lust rather than need.

Exercise 2 Next . . . expunge color from the scene. Choose a flat, gray light, a drizzly, damp, depressing day. Now summon up a blisteringly hot, golden summer's day, go to the West Indies in your mind, irradiate the dreary scene in front of you with all the colors of your memory and your imagina-

tion. Invest your drawing with joy and pace, optimism and heat. Don't get muddy. Once you reduce a page to a sea of sludge it is impossible to drag it back into the land of the living. Be clean and bold, enjoy yourself as the color transforms the image in the room to a story on the page. Decide whether to absorb the subject into the overall mayhem on the page or whether to pull it clear, by manipulating the color. Don't be afraid of making the figure blue or green if this is what it takes to distinguish it from the background. Avoid separating color out by surrounding sections of it with a black line; this will deaden the effect the colors have on one another and greatly reduce your range.

Exercise 3 Use color to reach the subject. Pose the model, or place a plant, in the middle of a pile of printed fabrics so that you are looking at a vista of multicolored zigzags, spots and swirls. Work in meticulously

BELOW
John Dougill
Figure in an Interior of Pattern and Color
Watercolor, 10 × 7 inches, 25.6 × 17.9 cm)
Spontaneous watercolor conveys atmosphere and the presence of the model even though the range of color and tone is spare.

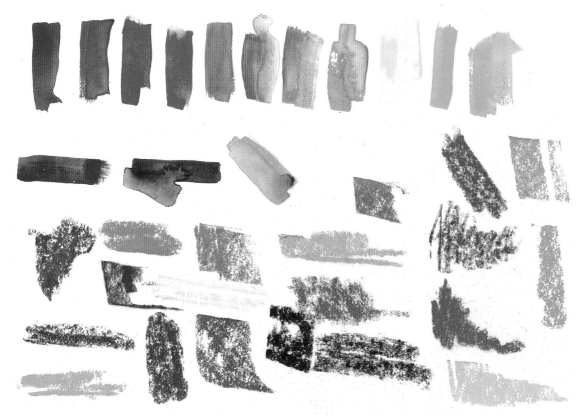

LEFT
Color dictionary. Brands
are not consistent so notate
your colorways as you go
along.

BELOW AND FAR RIGHT
BELOW
Viv Levy
Irises and Daffodils
Watercolor, 15 × 11¾ inches
(38.4 × 30.1 cm)
There is no underdrawing;
the color is used directly
from a limited palette.

RIGHT ABOVE
Viv Levy
Reclining Nude, Back View
Watercolor, 5 × 6¾ inches
(12.8 × 17.3 cm)
Blocks of color are put
down spontaneously as
metaphors for light values.

RIGHT BELOW
Viv Levy
Lemon Geranium
Watercolor, 7 × 4½ inches
(17.9 × 11.5 cm)

from the perimeter of this patterned sea toward the subject. Stop when you get there and return once again to the outer edge. Repeat this process until the subject emerges. Stand back from the work and make a decision about the empty space that is the model. Find the color to make the model the subject of your picture: are you going to fight against the intricacies and detail on the rest of the page or top it? Gauge the mood of the model; what color is it? Look at the way Matisse handles color and pattern to describe the character and presence of his sitters.

The longer you gaze into the heart of a color the more you will see that a 'color must be more than a color'. Look, for example, at the work of Mark Rothko. The intensity of a color can suck you into its core or see you off, lure you or repel you; there are colors that you can almost smell. Combinations and patterns of color can trick you into seeing double, make you squint, exhaust or animate you, can make surfaces vibrate or still them. We all have colors for the days of the week, colors for numbers. Color evokes memory, and has different symbolic meanings for different cultures; it has the poignancy of music, the economy of poetry. Find the colors analogous to your experience and choose your palette to describe what you see; no one else's formulae will do. Learning lines by rote will not improve performance.

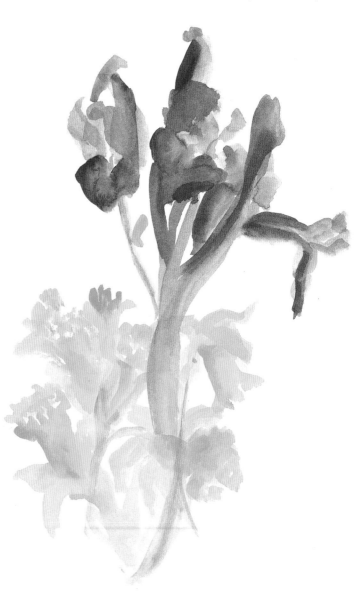

It is hard for me to be rational about color. Its potency is violently opposed to a common sense approach; I don't know of one. I love it too much. When I talk about it I gesticulate more than usual and raise my voice to those untouched by it. I have met students who flatly announce that they 'hate color' and I feel an irresistible urge to stick a rocket under them, to literally make them see red and to try describing that to me in black and white.

'When an artist gives up colors and moves into black and white he is clearing the decks for something new, freeing himself for fresh experiment.' So said American painter Barnett Newman. You must, however, experience it before you can give it up; you can't end what you haven't begun. Don't be afraid of color; it is powerful tool.

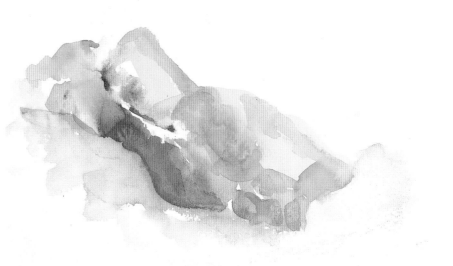

10. Abstracting Form and Seeing Pattern

'That paper cut out there, the kind of volute acanthus, is a stylized snail. First of all I drew the snail from nature, holding it between two fingers, drew and drew. I became aware of an unfolding. I formed in my mind a purified sign for a shell. Then I took the scissors.'

'Scissors can acquire more feeling for line than pencil or charcoal.'

'Cutting straight into color reminds me of the direct carving of the sculptor.'

– Henri Matisse

There is nothing mysterious or 'difficult' about abstraction. It is a further distillation of your looking and editing. Success will depend on how much you have drawn and drawn, whether you have begun to see the unfolding and learnt to recognize patterns. The novelist Doris Lessing speaks of the unrelenting search for a 'pattern of words' in order to be able to say what she means; the visual artist, also, is on a quest for a personal and expressive pattern of marks. The 'patterning' of the subject matter is going to serve, at first, as another means to get you to see with fresh eyes. Later on we will pick up the pieces and gather them into personal statements.

Exercise 1 Collect together all the old wrapping paper and colored scraps that you can lay your hands on. Select a pair of sharp scissors. Equip yourself with a stick of glue. Set up the subject, animal, vegetable, or human, so that it allows you a fairly simple view. Draw the subject over and over again, with a view to finding a distilled version that still 'reads' true; don't founder into caricature. Set down your pencil, take up the scissors and cut out pure shapes. Be bold and trust the discoveries you made in the drawings. Do not cut out shapes to fit into and glue on to existing drawings. This is a new venture; you are using the learning from the drawings to give you a head's start.

Push the cut-out shapes around the page until you feel that they are coming together into a coherent pattern; stay lively and direct and try to say as much with as little as you can. Glue down your decisions.

Tackle the same pose by cutting out and keeping the negative shapes. Find the air, the space, that surrounds the model, that weaves between leaves and around limbs. The model will be the white that's left behind.

Creation begins the instant you put two elements together to make a third. Everything you add or subtract will change the nature of the whole. With collage you have

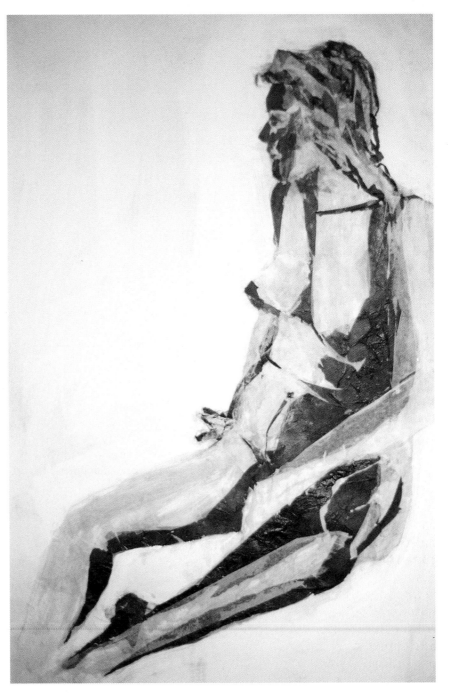

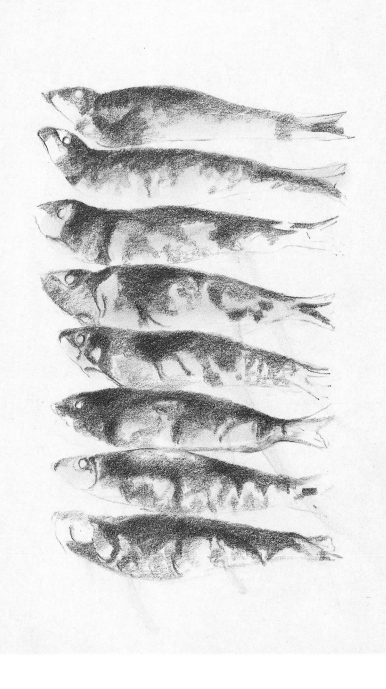

Jane Ackroyd
Collage
Black paper on white.
This was the master
drawing for a vast pair of
steel gates; subjects were
cut out and moved around
until they created the
desired configuration.

Viv Levy
Anenome
Watercolor
Abstracting the color and
life of the flower.

Viv Levy
Fish
Pencil
Using the markings on the
fish to create a pattern
down the page.

the chance to experiment before sticking
your decisions to paper; this is the thinking
that goes into the making of constructed
sculpture. There is nothing random or un-
schooled about it; you should retain the
spontaneity of a five-year-old child but also
use your experience and your seeing.

Cast your mind back to the exercises you
did with light and dark (page 48), how you
were able to find patterns of shadow and
allow the model to emerge by trusting to
'abstract' thinking.

Exercise 2 You are going to work this next
drawing in black and white tissue paper.
The transparency of this material will enable
you to describe permutations of tone by
layering and alternating between black and
white. You can either work with glue or dip
the scraps of paper into shellac for a shinier
more translucent finish. I find that tearing
the paper is more satisfactory than using
scissors; the edges are softer and I like the
feeling that I'm almost modelling with tone.

Start by laying down the black tissue, the
darkest patterns that you can see, and then
pull them into the light with the white
paper, using the overlap to describe subtle
changes of tone. Be selective about the mass
of information in front of you. Talk to your-
self: why this? Why not that? Is this decision
crucial, is a pause more vocal than an un-
interrupted run? The nature of the material
precludes the rendition of minute detail,
and omission is as important as inclusion.

Keep stepping back from your work because the large reductions you will have been forced to make are indecipherable at close range. The acid test is if your work 'reads' from the other side of the room; if it begs closer inspection.

Once you have learnt to transcribe what you see you can begin to articulate a more subjective and emotional view, to challenge the mind of the spectator as well as the eye. You will realize that what the eye perceives is no longer complex or complete enough and you will want to embellish the story, capitalize on the fictions necessary to every kind of representation.

'The scale conception involves the relationship of objects to their surroundings, the emphasis of things or space,' according to Mark Rothko. In the chapter on planning the page I mentioned playing around with placement and scale (page 20). There definitely is such a thing as space 'emotion'. A child may limit space arbitrarily and then focus on his subjects, or he may infinitize space, dwarfing his subjects, causing them to merge and become part of the space of the world. Take this opportunity to start experimenting; with your cut-out elements you will be able to move components around the picture space with ease and change the relative scale of model to surroundings, without committing yourself until you feel that you have got the emotion right. A tiny figure at the front of the picture, or a huge one on the horizon, a figure or a plant barely entering

ABOVE LEFT
John Dougill
Shapes culled from the dark organize themselves into a walking female figure.

LEFT
Viv Levy
Figures on Hampstead Heath
Paint, pastel, tissue paper, 36 × 48 inches (92.1 × 123 cm)
This was a remembered impression of a walk on a stormy day.

RIGHT
Henri Matisse
Blue Nude 1, 1952
Gouache cut-out, 41¾ × 30¾ inches (106 × 78 cm)
'Cutting straight into color reminds me of the direct carving of the sculptor', said Matisse.

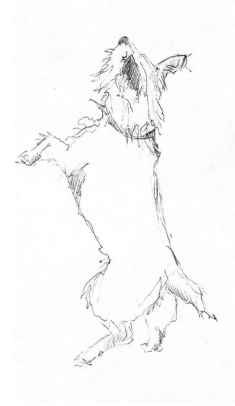

LEFT
Viv Levy
Small Dog Performing
Ballpoint, 6¼ × 9 inches
(16 × 23 cm)
Placement itself has
meaning. Had this dog
been drawn center page he
would have been a simple
illustration; placed to the
side he poses a question,
sparks a narrative.

BELOW
Viv Levy
Dead Irises
Pencil, 14 × 10½ inches
(35.8 × 26.9 cm)
Drawn down and across
the bottom of the page, like
a decorative border.

RIGHT
Matisse
La Marocaine
Oil on canvas, 13½ ×
10½ inches (35 × 27 cm)
Wonderful combination of
color and pattern.

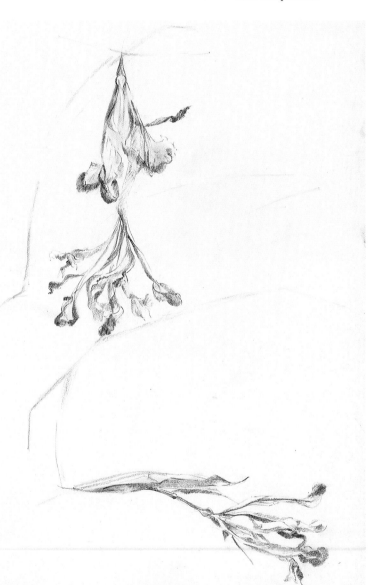

the frame or the rear end of an animal leaving an empty page; placement itself has meaning. The location of marks on paper, the endless permutations of color and situation, whether you are dealing with figuration or hovering on the brink of abstraction, the way you order the page, can all alter the significance of a drawing. Drawing is a search for visual codes, for a personal language. You can alter the outcome of a story by changing one line, by the amount of importance you ascribe to a particular insight. Pick up the pieces of your seeing and rearrange them to underline YOUR thinking. Start to use more than clinical observation alone, see, feel and then draw. The oldest and most obvious form of abstraction is music; we accept abstract patterns in our minds when we listen to music. We also accept, expect, the emotive effect of music, take for granted the journeys through time and space it takes us on. If you find the translation from audio to visual too obscure, try playing music while you draw, make the drawing about the sound, allow it to alter your seeing, don't treat the music as a vague background irritation. I often get people to draw the same pose to different pieces of music and the effect is electrifying; find the sound of yellow, the color of whale song.

Do the kind of work that has an element of second chance to it, so that the spectator can have the added pleasure of reading his own solutions into it.

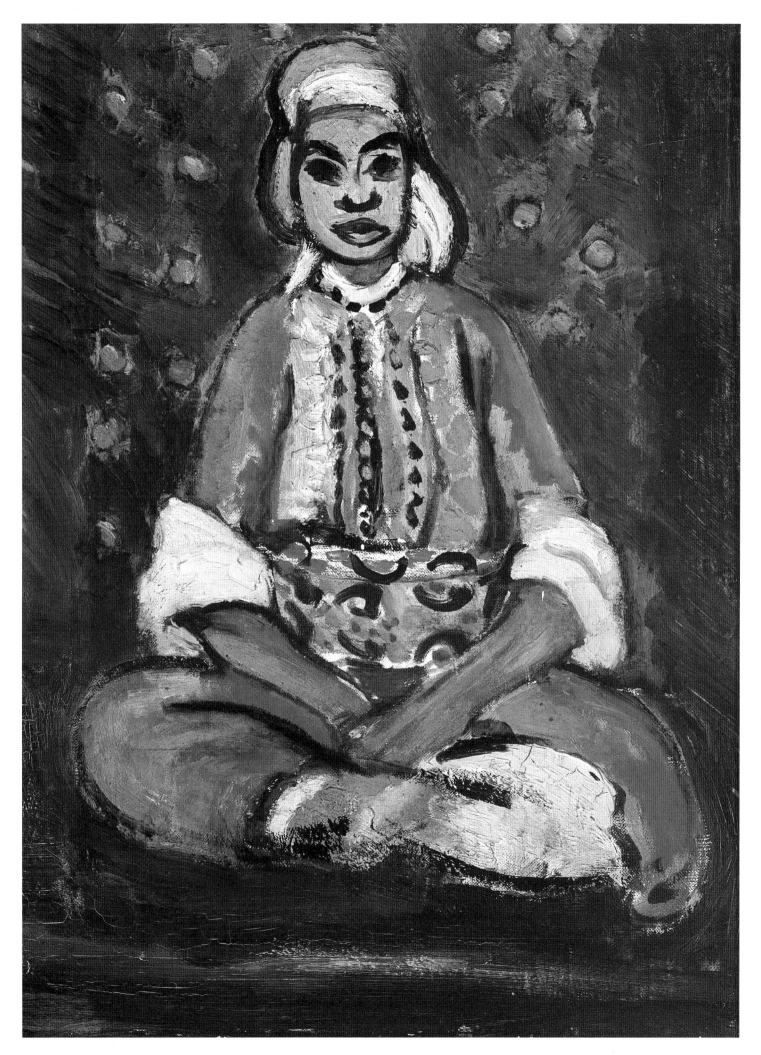

11. Getting into a Mess and Extricating Yourself

'All may yet be well.' – William Shakespeare

There is a Spanish word for it, *'marana'*. It is more or less untranslatable, implying tangle and creation simultaneously. The webs you weave will rarely echo the perfect economy of nature; you will get into alarming tangles along the way and will probably cast around in despair for something to take your mind off them – the ostrich solution. When I was a student I inadvertently discovered the value of sticking with the chaos when I was so downhearted that I felt that even hope was gone. I sat up all night worrying at a drawing until my eyes were popping out of the top of my head and the mess I had created seemed so impenetrable that the only sensible move was toward the bin. I'm not that sensible. The next day someone saw the drawing and bought it, for what was to me an enormous sum. I realized that the mess had provided me with unforeseen problems to resolve and that by sticking with it I had added to my vocabulary and had extricated a new and exciting piece of work. Had I trashed it and simply started again, I would have fallen back on habit to reproduce something acceptable, and would have come up with yet another competent drawing that would have attracted no more than a perfunctory glance, and certainly no cheque to replenish my grant and boost my flagging confidence.

It is, of course, foolish to suppose that there is an advantage to be gained from sullenly and deliberately making a mess for its own sake, setting up provocation to generate alternatives. The self-conscious tangle contains few surprises and no rationale for working your way out. Simply making a mess is like committing suicide; you are inviting disaster, making it your goal. Always set out to do the best you can. Should you founder along the way, however, don't despair; pinpoint the problem and yank yourself out.

I have certainly never made the perfect drawing; I don't know what that is. I still get stuck and think that there is no way to get going again or to alter course. This exercise usually helps. Set out to make your idea of a bad drawing: not a mindless mess, but a quiet, conscious effort to flush out your worst habits and to consign as many of them as you can find to one drawing. This is not making disaster your goal, it is about learning to identify your bad points and explain why you think they are bad. Paradoxically, you will probably find that the naming of transgressions will shame you into making a

RIGHT
Viv Levy
Rome Dog
Pastel, pigment, wash. This drawing followed a short trip to Rome. The color and texture of remembered walls provided the ground and the stylized dog was then drawn on in complementary colors.

very good drawing. With the 'hideous' prototype by your side, reverse tactics and treat the same subject to a purged version. Which is the better drawing of the two? Take this exercise seriously; it is not an invitation to stop thinking or collapse into indifference.

Accidental mess can be turned to your advantage. An involuntary dribble may conveniently wrap itself around a form you had been worrying about. Take note and, instead of instantly and angrily obliterating it, use it to strengthen and enrich the pattern of marks on the page. Eradicating mistakes with white paint will provide a new surface for the correction to be made. You may see a way of using this new surface deliberately on the next drawing by preparing a whole sheet of paper with paint and leaving in the brush marks. A spill, the splatter of ink from a broken nib, a tear or a crease in the paper, all these incidents can be exploited. Take a look at Ralph Steadman's drawings, where mishaps are put to magnificent advantage. Jackson Pollock, Jack the Dribbler, was able

BELOW, BELOW LEFT AND FAR LEFT
Viv Levy
Quince Locked Out
Pigment, pastel, water, charcoal.
These drawings evolved from three quick sketches of my dog on the move (see next page). Each one began in chaos as I piled on pigment to suggest a view through a cold and dripping window. I found Quince and his place on the page by using the accidental reactions of the different media and the shapes they formed and then organized them into 'dog', 'window frame', 'back wall', etc.

LEFT
Viv Levy
Night Vision in Turkey
I used everything including
the kitchen sink on this
picture, created total
mayhem and finally
managed to extract a result.

BELOW
Viv Levy
Quince Drawings
Pencil

to predict an apparently random flick or
fling of paint at thirty paces.

That sinking feeling, the paralysis caused
by the initial confrontation with a pristine
sheet of paper, the perfect empty space, can
be overcome by judicious fouling. Don't tor-
ture yourself, take courage. Unfreeze the
page, cover it with a less intimidating face to
draw on. Cover the paper with pigment or
paint, or size it, or spray it with water. Make
your first move a confident one and trust
yourself to find a way out of your made sur-
face, or a way to grind back into it. Allow the
mystery of the involuntary gesture to work
for you as another exemplar of what goes on
in life; look into the abyss but be obsessive
about getting out of there. Uncover every
facet that you can, all the ramifications of the
shapes on your page, don't pre-empt before
examination.

One of the most exuberant and inspiring
lectures I have been to was given by a
painter called Albert Irvin. One particularly
memorable line stuck in my mind: 'Without
ham there is no sandwich.' Don't, in other
words, ever be afraid of going over the top or
getting into a mess; you can't find what to
exclude until you have seen what could be
there. You can always find your way out of a
mess but if you are too uptight to allow your-
self to get into one in the first place you will
be leaving yourself no room for improve-
ment. Don't, like Prospero, break your staff
and resign.

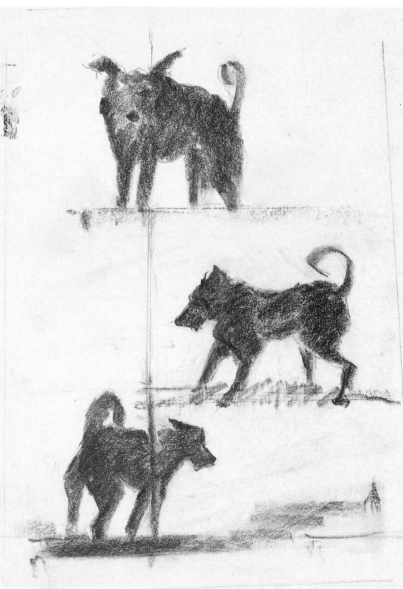

LEFT
Rembrandt
Sketches of Heads, 1666

BELOW LEFT
Jane Ackroyd
Paint
Using accidental drips to advantage. This tiger is positively drooling; his stripes are merging with the background and providing the same camouflage as they would in the wild.

12. Conclusion

'I'm always astonishing myself, it is the only thing that makes life worth living.'
— Oscar Wilde

'Art is a lie that makes us realize the truth. The artist must know how to convince others of the truthfulness of his lies.'
— Pablo Picasso

Drawing is not a confession of weakness, although it can feel uncomfortably revealing. A sheet of white paper lays bare inadequacies more clearly than any mirror, but remember, your aesthetic preferences are neither right nor wrong. The most important thing is to become confident enough to use your medium in a pure, unsystematic way; to learn to look, to accept what you see, and to be open enough to operate on various levels of reality. Once you have achieved a convincing illusion of visible reality, you will be free to find ways of reassembling all your 'seeing' and 'thinking' into a mirror of your own universe. I have deliberately steered clear of a didactic approach to drawing, 'correct' proportion, the 'rules' of perspective, in order to get you to see for yourself. You cannot draw with your nose in a book, you will inevitably 'need' information that has been overlooked. I have tried to sidestep this problem by giving you things to do rather than a list of instructions to abide by.

Picking up a guide and expecting a foolproof blueprint for survival and success is tantamount to joining a sect and abdicating responsibility. A new cookbook will not turn you into a masterchef over night, although it might give you some good ideas. The recipes, the flavors they yield, are the results of years of labor and invention on the part of their authors, and the presentation of a dish

BELOW
Rembrandt
Elephant
What can I say? Look, enjoy, recognize.

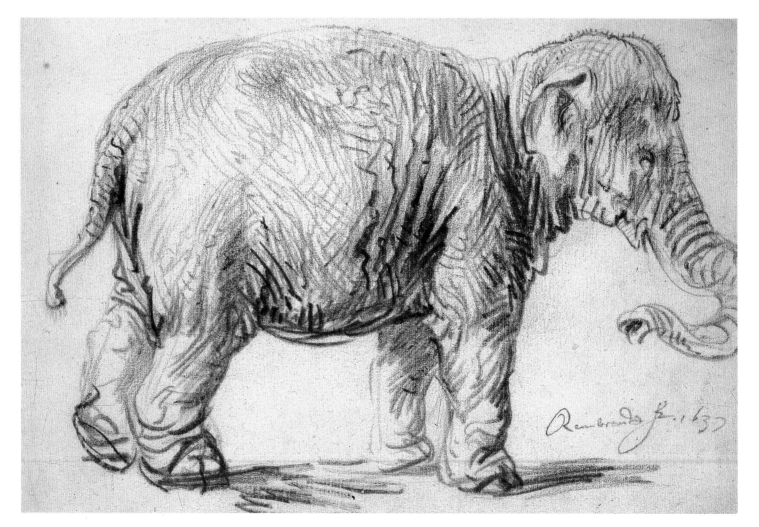

will also affect the way it pleases your palette. There is a subtle, personal touch that con't be conveyed secondhand. I wish I could invite you to my table. In the meantime, choose the right ingredients, mix them in the correct quantities, and serve up a delicious conclusion. I have read dozens of recipes for Boeuf en Daube, Beef Casserole, Boeuf à la Mode, Boeuf aux Olives, Beef Stew, Irish Beef Stew, Provençal Beef Stew, Stifato, Greek Beef Stew, and they all make mouth-watering reading. In the end I invented my own version, my own concoction of meat, vegetables, liquid, cooking times and temperatures. The result is delicious, suits my budget, and the ingredients are available locally. I took from the recipes the affirmation that a passionate cook loves to eat. I love to draw, to peer at the world upside down and inside out like a latter-day Alice. With a few additions and deviations, this book is a homage to the way I was taught to draw, and I hope I have been able to pass some of my enjoyment on. 'Patience is the sister of mystery and tirelessness the best of all roads,' (Aleksis Rannit).

I have one more suggestion up my sleeve. Keep a visual diary. Do at least a drawing a day in a book intended for your eyes only. You need only spend five minutes on it, but find the time and the discipline to make a statement about the day, every day. It may be an apparently insignificant detail of the day, or an emotion, a portrait, a self-portrait, the impression of a tenacious dream, some fleeting thing spied out of the corner of your eye, a color or an abstraction signifying an overall atmosphere. Date each page and don't alter or rip out pages you dislike, or title or explain the image with the addition of words. At the end of the year you will have at least 365 drawings. Some of them will have hit the spot and will recall for you, like a rediscovered taste, the exact atmosphere of that day, the sound of it, the temperature, your state of mind and body. Others will leave you blank and puzzled. You will have a valuable book of clues, you will learn to read your own handwriting, and to pick out the formulae that work for you, by you. When you feel the hairs rise on the back of your neck as the potency of something you have made brings time past into sharp relief, you will know that the alchemy is working.

The time will also come when you stop defining others as you would like them to be, but rather as you see them. We all have a tendency to make self-portraits; involuntarily we make small models tall because we

LEFT
Viv Levy
Page from the Diary
Watercolor.
Evocative of the atmosphere in Turkey: the colors of a house glimpsed in the hills, sky above, smell of the sea.

BELOW
Maggie Jennings
Marked with Black Pollen
Mono screen print, 36 × 28 inches (92.2 × 71.7 cm)
Color, exuberance and flair, extracted from memory and transformed into theater.

are tall, thin models fat because we are fat; we use the experience of our own bodies to see others. Alien species are easier to see, although it is said that we look like our pets (I do hope so). This is because we are looking at something 'other', something that we experience with more curiosity, to understand about flying, moving around on four legs, being rooted to the earth. These things we cannot take for granted. Use your eyes and your feelings to discover the unique qualities of your fellow bipeds; they are not walking around in the same body as you.

I can't time drawings for you and tell you when to stop or when it's worth bashing on. As a disembodied mentor, I cannot demonstrate my way of achieving a mark, rip your work from the drawing board and make you eat it, or come down hard when you veer from the purpose of an exercise. You will have to treat this guide as an open door, an invitation to adventure. Continue to look at the 'Old Master' drawings and the work of your contemporaries. Emulate the seeing and co-ordination that you respect, don't try to jump the gun and simulate their results. Try, by all means, to make drawings 'in the manner of' or 'in the school of', but make them for better understanding, not for the sake of making an impressive copy.

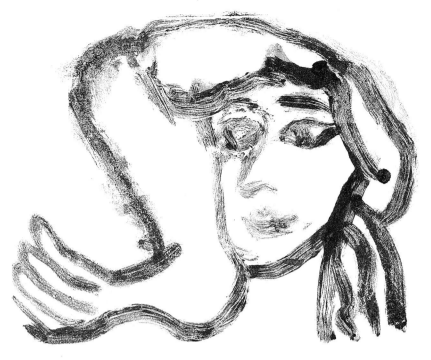

I have a friend, a lawyer, who is also an excellent draftsman. He had never had a formal class in his life, but spent a lot of his spare time making entertaining drawings for his friends. They were full of humor, vitality and acute observation. Came the day he decided to attend a Life Class to learn to do it properly. The model was posed and left prone like meat on a slab, the tutor lurked around the perimeter of the class, unwit-

ABOVE
John Dougill
Litho.
I love this print. Head, hand, the very nature of the drawing, conspire quite simply to say more than the sum of its parts.

RIGHT
Viv Levy
Reclining Nude, Back View
Charcoal and pastel.

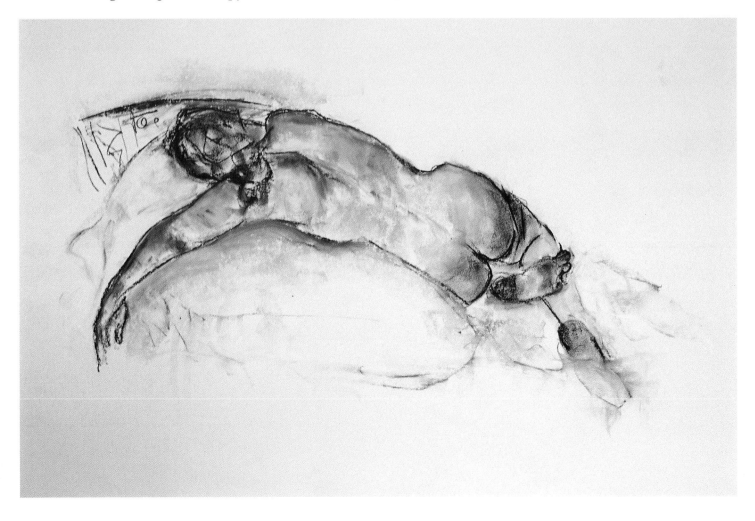

tingly creating a tense and uncomfortable atmosphere, and no instructions were forthcoming. My friend seized up, unnerved and without direction, and turned out the weediest and most meaningless drawings he had ever made or I had ever seen. They weren't even magnificently misconceived, they weren't conceived at all. He was so depressed and discouraged, so intimidated by his first experience of drawing in public – and remember that this is a man who is used to dealing with dangerous criminals without turning a hair – that he gave up drawing altogether. An all too familiar tale. I tell it to beg you not to be put off by bad experiences, which we have all had; not to be discouraged by your failures, not to let the disastrous days knock the stuffing out of you, but to hang on like grim death to the elation your feel when you have achieved a success. There is no one to judge you, you can make mistakes and celebrate your triumphs.

As a teacher, I use the exercises in this book sparingly. I might set and work through one or two of them in the course of a five-hour teaching day. I spend time making sure that the students know what they are doing. I sometimes get the impression that they think I invent increasingly impossible hoops for them to jump through, to gratify some particularly sadistic streak in my nature: death by drawing. At the end of the day, however, with a pile of new drawings

LEFT
Nicola Hicks
Dead Chickens
Charcoal, pastel on brown paper.
Medium and subject matter eloquently combine to send shivers down the spine.

under their belts, those who have enthusiastically submitted to the tyranny emerge, shell-shocked, but pleased with the fresh information that they have essentially seen for themselves. We work hard, laugh out loud and sweat blood. The days vanish at speed.

'Astonish yourselves.' – Viv Levy
'Drawings are, usually, not pompous enough to be called works of art. They are often too truthful. Their appreciation neglected, drawings remain the life force of the artist.' – David Smith

LEFT
Viv Levy
Rome, Dead Dog
Pastel, pigment, wash.
I pushed color and texture into the paper and almost embedded the image.

RIGHT ABOVE
Viv Levy
Nude and Cushion
Charcoal, pastel, 36 × 48 inches (92.1 × 122.9 cm)
I enjoyed this one, a fortuitous combination of a marvelous model in a dreaming pose. I enjoyed it so much I picked up some color.

RIGHT
Nicola Hicks
Fish on the Back of an Envelope
Black and white ink.
I love this one too. Perhaps started as a doodle on a piece of adjacent waste paper, but it evolved into an intense drawing, happily incorporating the stamp.

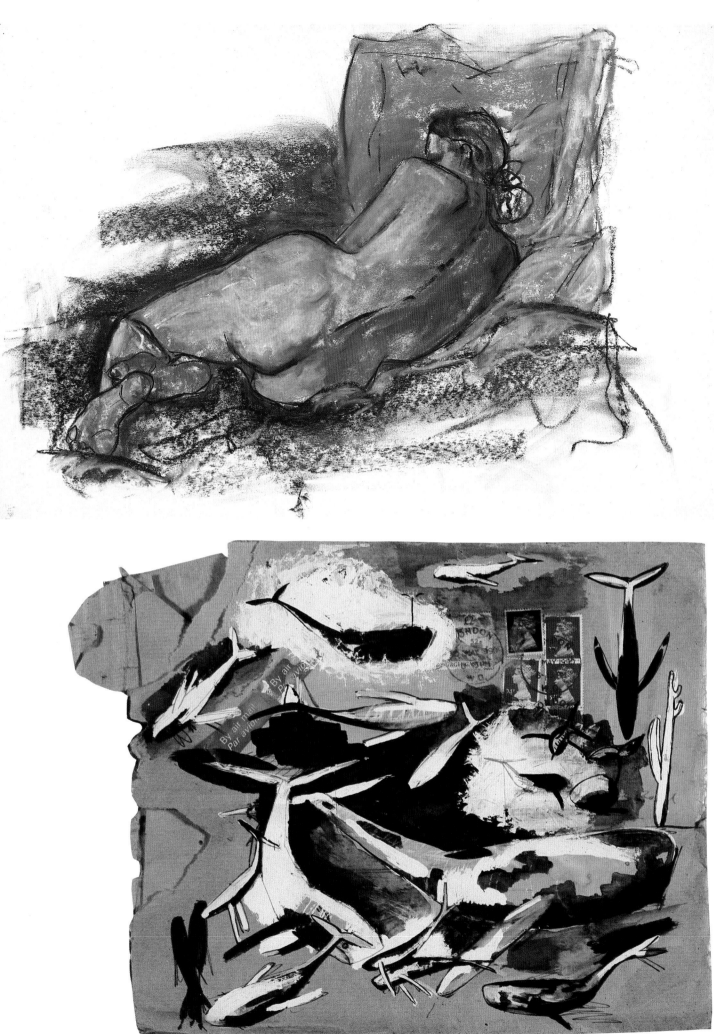

Index

Acknowledgments

The publisher would like to thank David Eldred, who designed this book; Pat Coward, who indexed it; and Jessica Hodge, the editor. We would also like to thank the following individuals, agencies and institutions, who loaned original artwork and/or supplied photographic material.

Jane Ackroyd: pages 65, 73
David Annesley: pages 37, 40, 41
Art Institute of Chicago, Alfred Stieglitz Collection, 1949.902: page 54 top left; Alfred Stieglitz Collection, 1949.895: page 55
Barber Institute, Birmingham/ Bridgeman Art Library: page 73
Beyeler Collection Basle © Succession Henri Matisse/ DACS 1993: page 67
Cabinet des Desseins, Musée du Louvre/photo Réunion des musées nationaux: pages 35, 40 (below)
Christies, London/Bridgeman Art Library: page 43 (top)
Dido Crosby: pages 4, 9, 11, 25, 28, 29, 33, 56
John Dougill: pages 30, 61, 66, 7
Galleria dell' Accademia, FlorenceSCALA: page 53 right
Graphische Sammlung Albertina, Viennaphoto Lichtbildwerkstatte Alpenland: pages 44, 74/ Bridgeman Art Library
Musée de Grenoble © Succession Henri Matisse/ DACS 1993: page 69
Harvard University Art Museums, bequest of Meta and Paul J Sachs: page 58 left below
Nicola Hicks: pages 56, 78, 79
Maggie Jennings: page 75
Brian Kneale: pages 10, 12, 22, 27, 45, 47, 58
Kumml Collection, London: page 28 below
Metropolitan Museum of Art, purchase 1924, Joseph Pulitzer Bequest (24.197.2) page 6
Adrian Montford: page 54
Perls Galleries, New York: page 42 top
Picasso Museum, Paris © DACS 1993: page 38 top
Private Collection/Bridgeman Art Library © Succession Henri Matisse/DACS 1993: page 43 top
Santa Maria del Popolo/ SCALA: page 51 below
SCALA: page 7
Windsor Castle, Royal Library © 1992 HM The Queen: pages 15, 34, 57 (below)
Yale University Art Gallery, Everett V Meeks, BA 1901 Fund: page 48